# BIG BOOK OF DRAWING ANIMALS

## 90+ Dogs, Cats, Horses and Wild Animals

 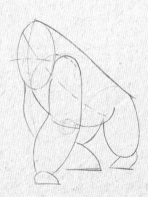 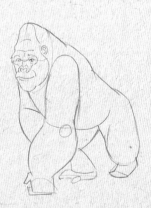 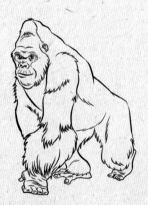

### P. Rodriguez & T. Beaudenon

**NORTH LIGHT BOOKS**
CINCINNATI, OHIO
artistsnetwork.com

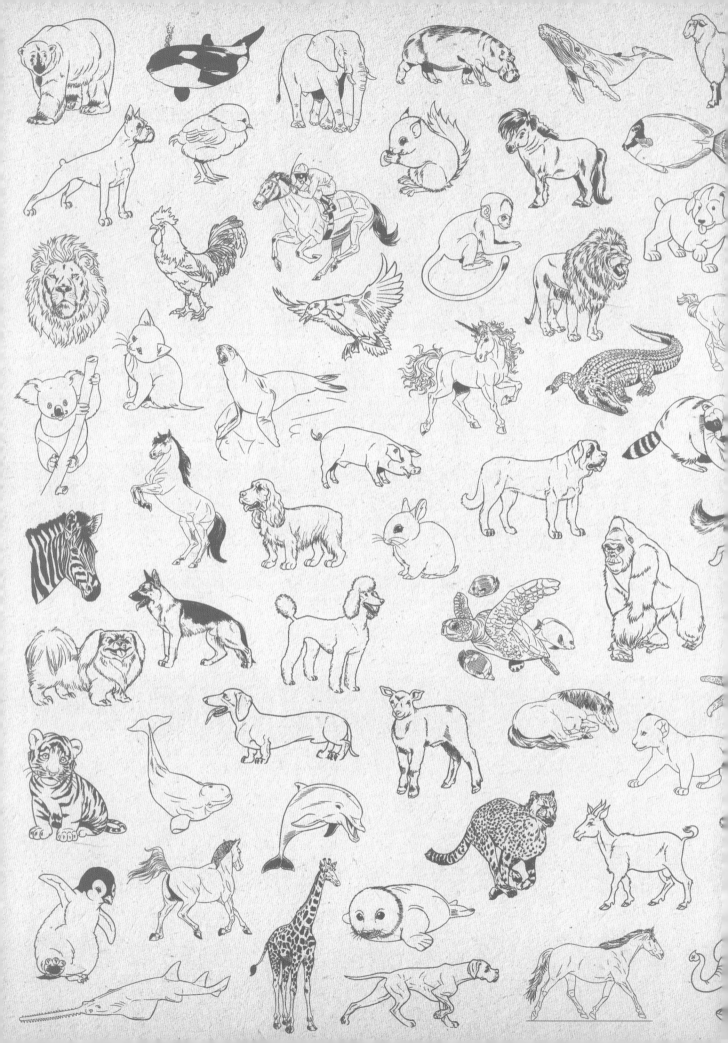

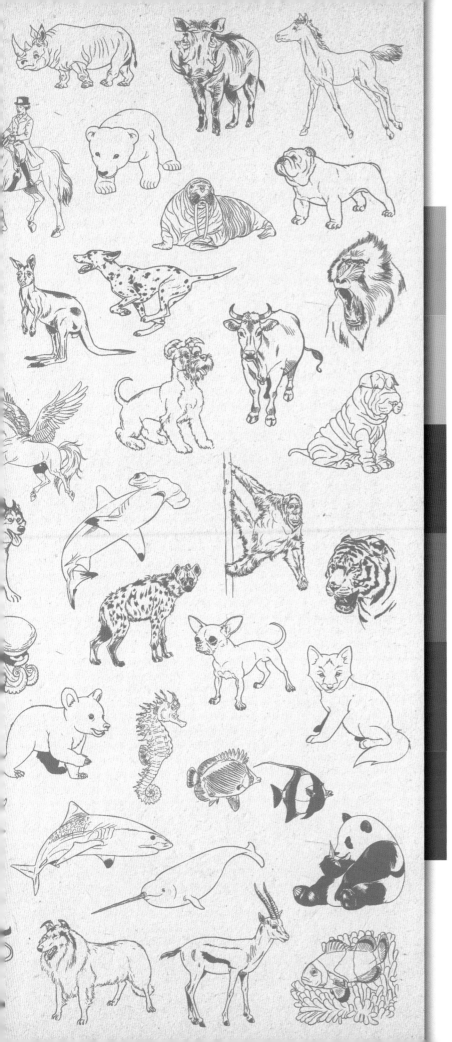

# CONTENTS

CHAPTER 1
## BABY ANIMALS
4

CHAPTER 2
## DOGS
40

CHAPTER 3
## FARM ANIMALS
74

CHAPTER 4
## HORSES
92

CHAPTER 5
## MARINE ANIMALS
116

CHAPTER 6
## WILD ANIMALS
150

INDEX
190

# BABY ANIMALS

## POLAR BEAR CUB

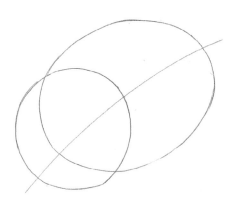

1. Begin with an oval shape for the body, and then a smaller circle for the head.

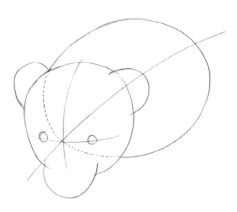

2. Place the eyes and the ears.

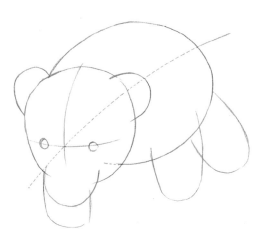

3. Begin to draw the legs.

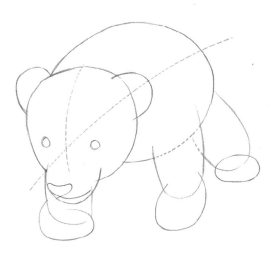

4. Add the nose and mouth, and then continue with the paws.

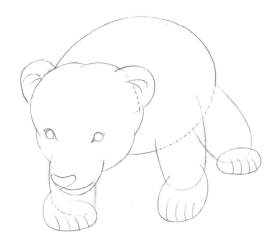

5 With an eraser, clean up the structural lines and then add a few details.

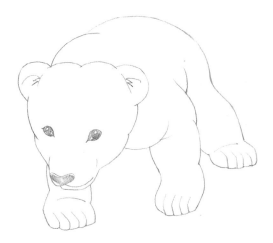

6 Finalize the pencil drawing.

7 Go over the pencil lines with a felt-tip pen or a brush with India ink.

# KITTEN

1

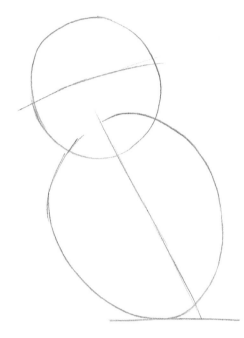

2

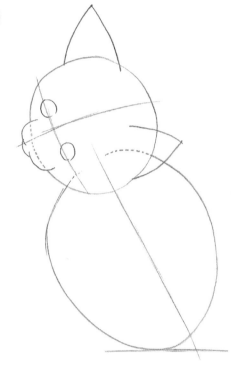

3

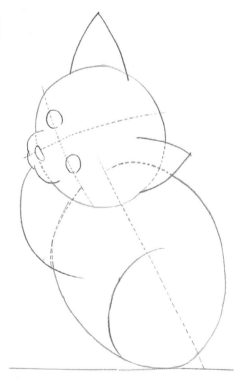

4

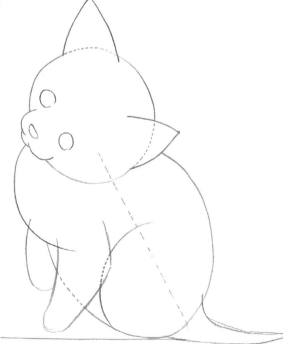

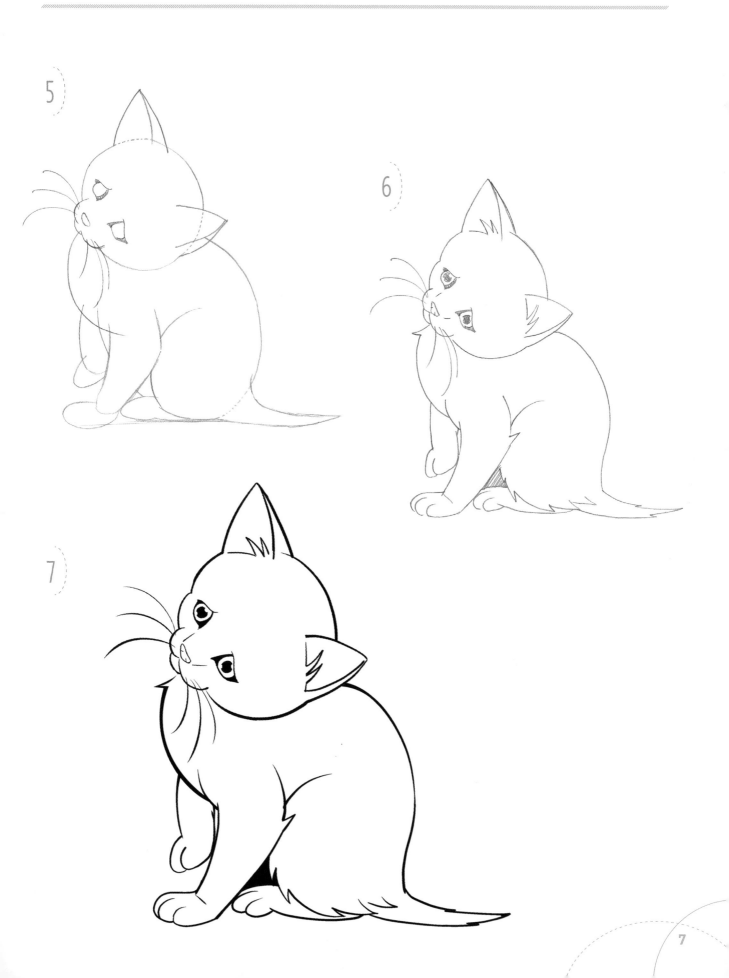

1
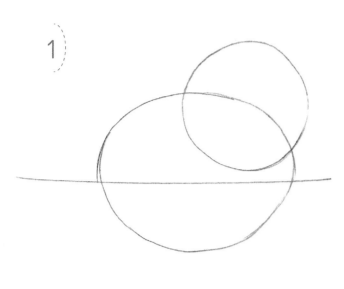

2
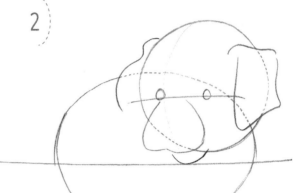

3
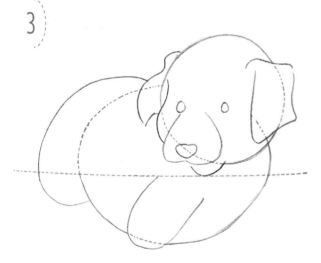

4
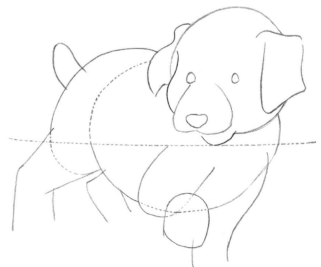

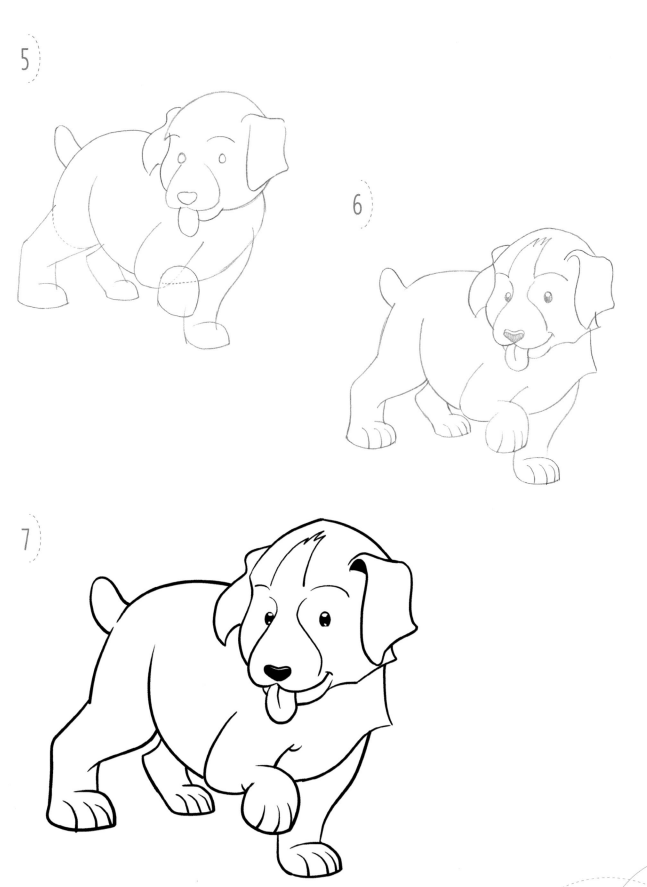

5

6

7

# BABY RABBIT

1

2

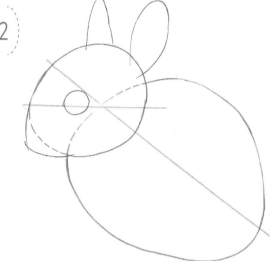

3

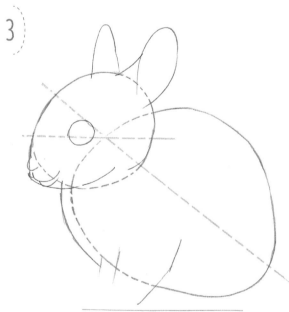

4

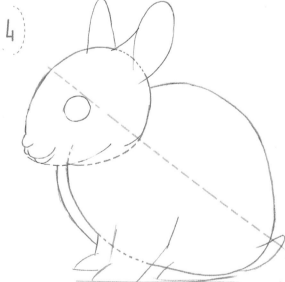

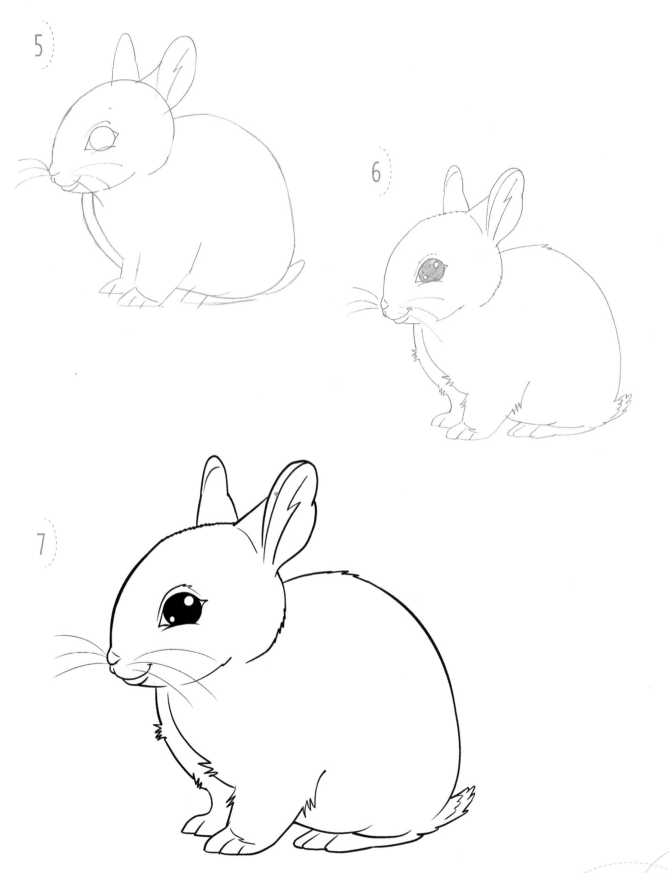

# CHICK

1

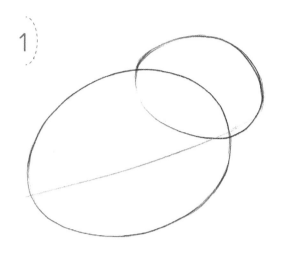

2

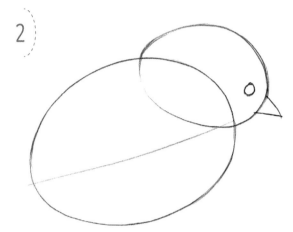

3

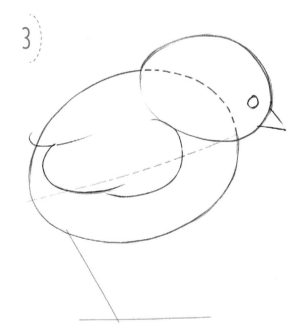

4

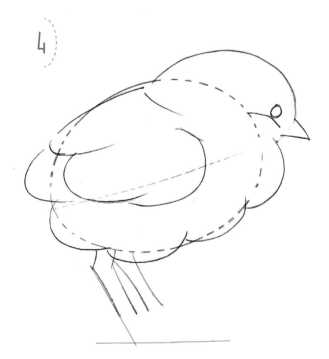

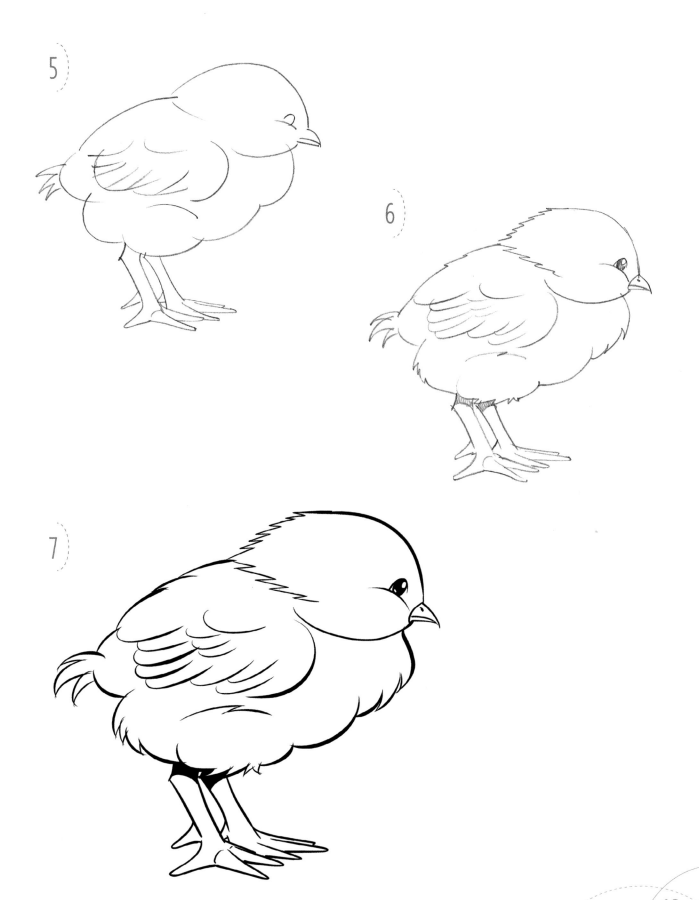

1

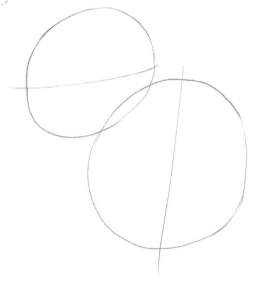

2

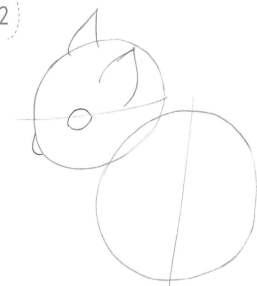

3

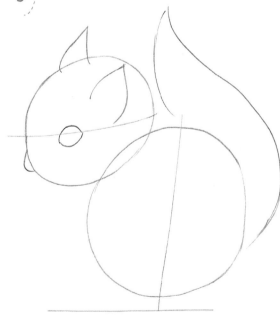

4

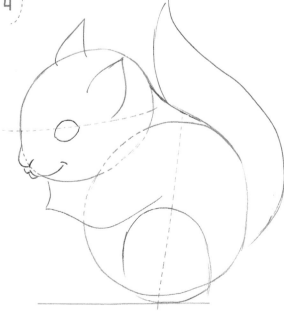

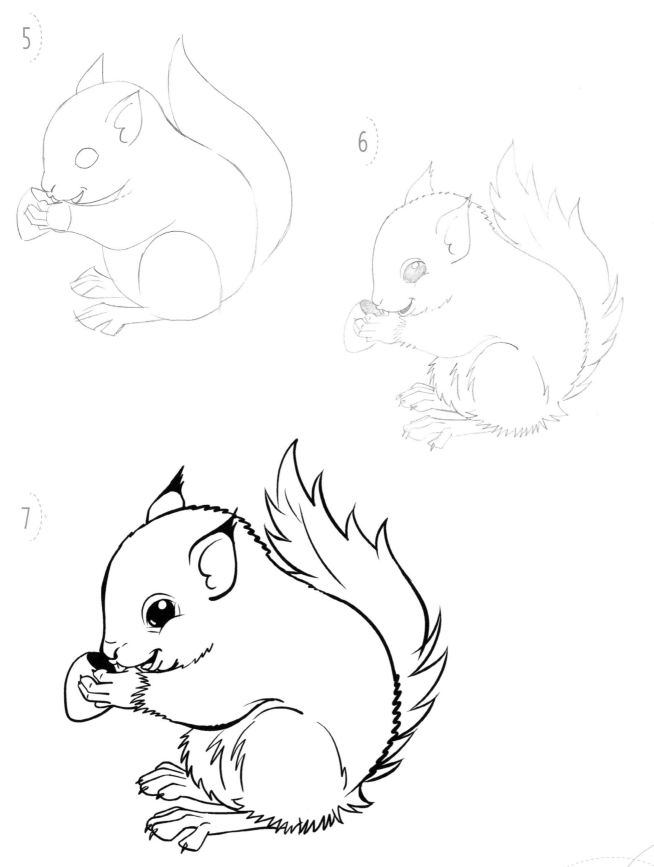

1

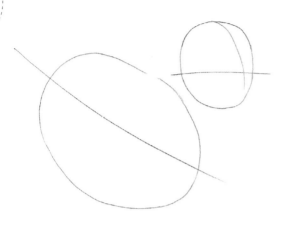

2

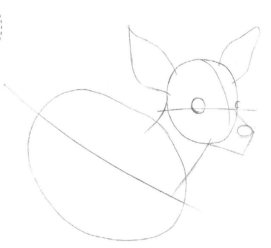

3

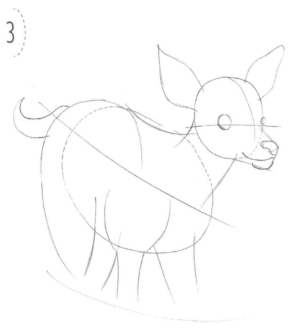

4

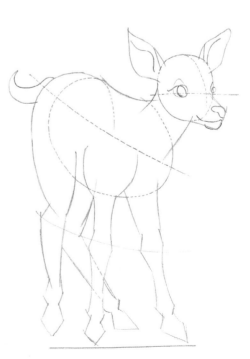

5

6

7

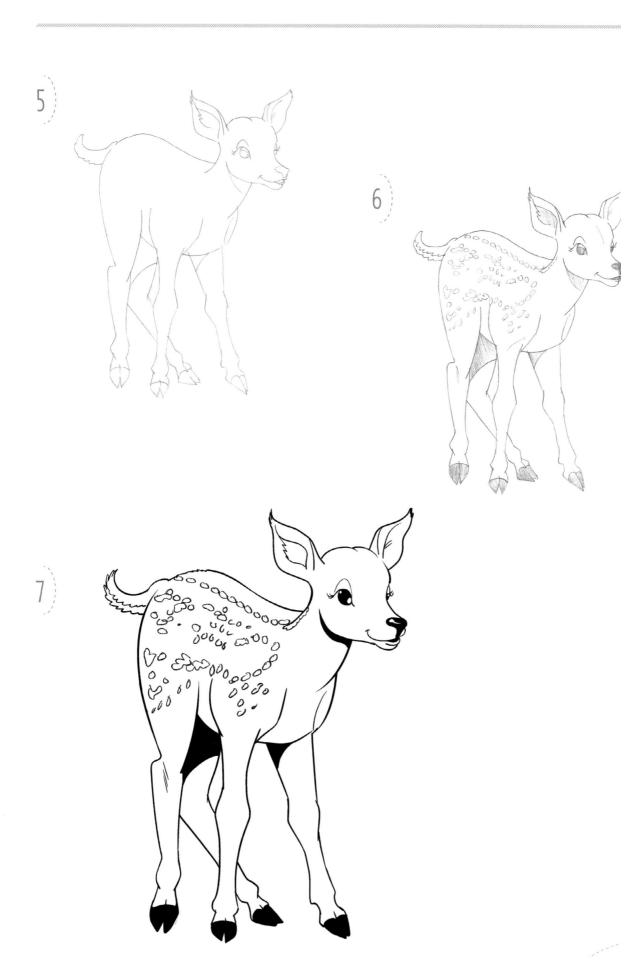

# BEAR CUB

1

2

3

4

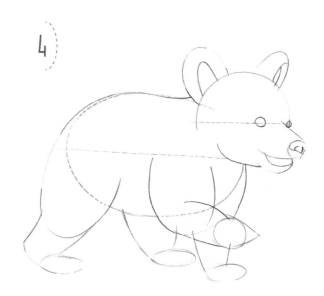

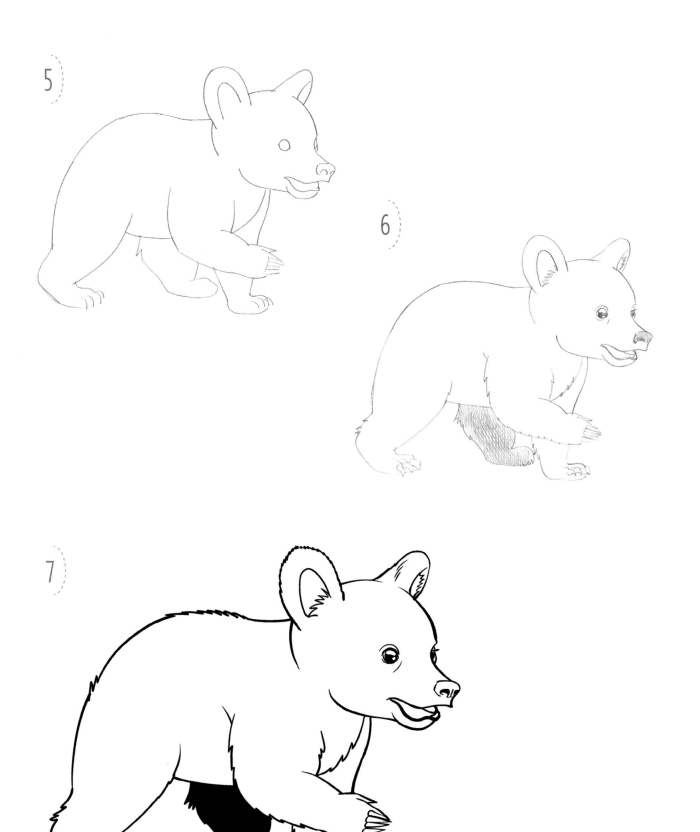

# BABY RACCOON

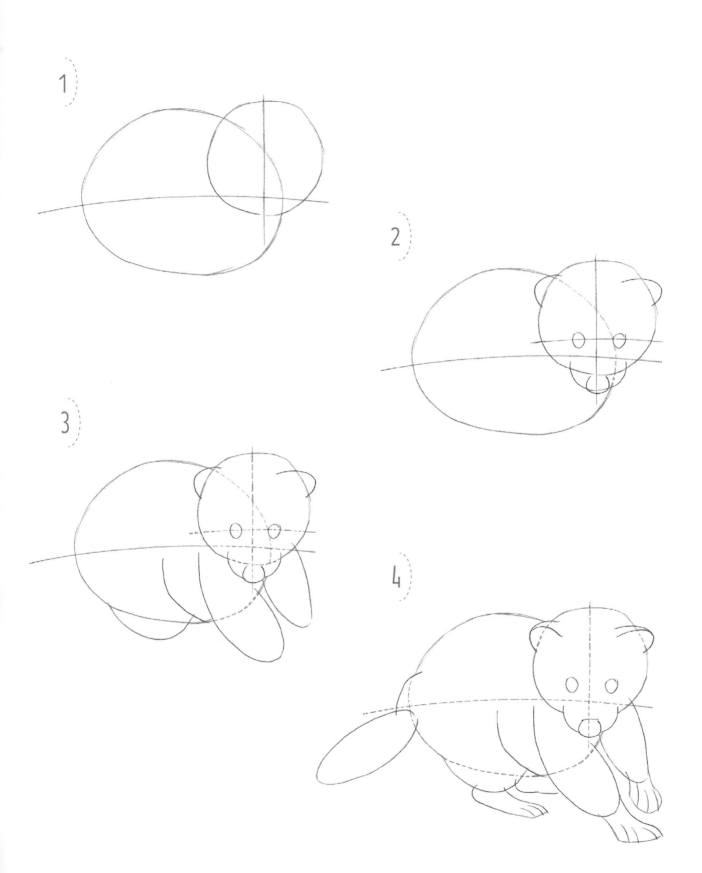

1

2

3

4

5

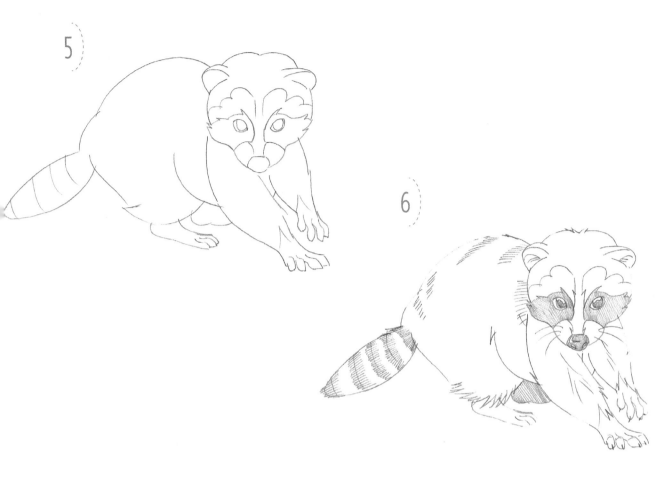

6

7

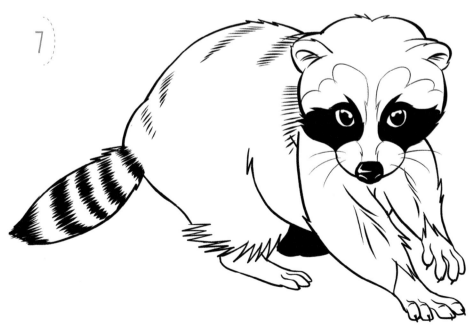

# ELEPHANT CALF

1

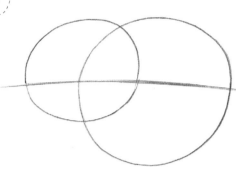

2

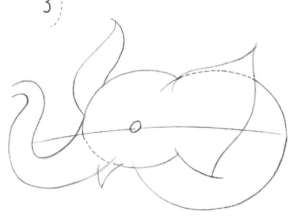

3

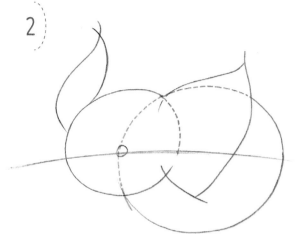

4

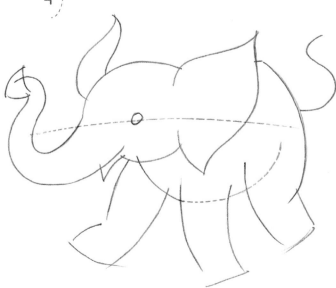

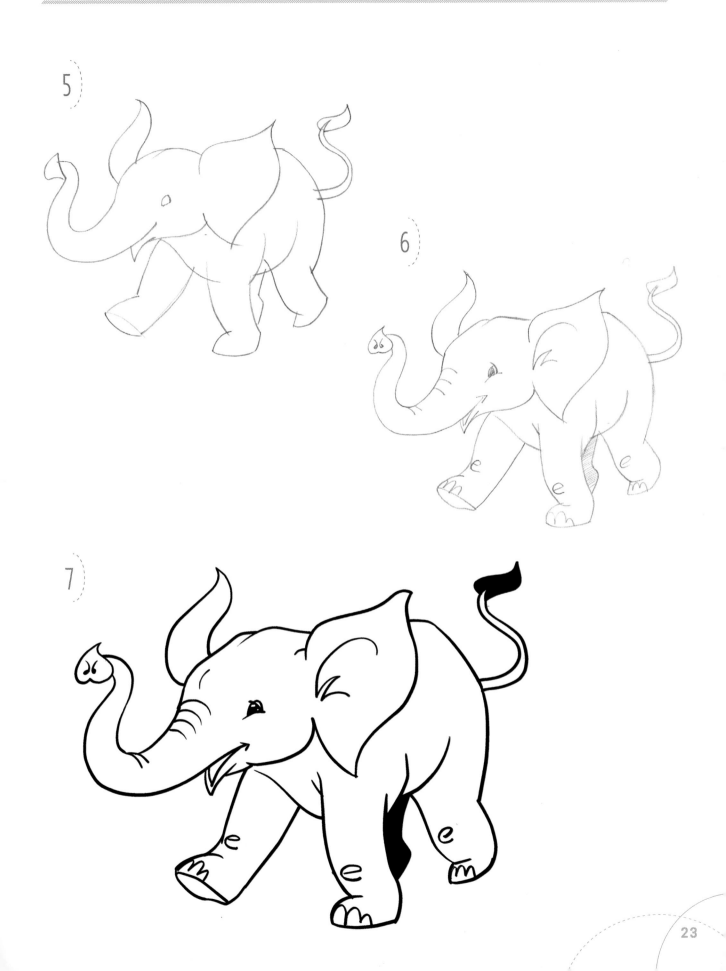

1

2
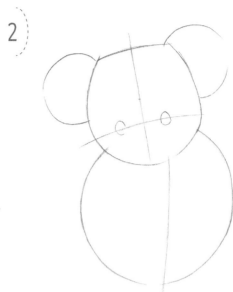

3
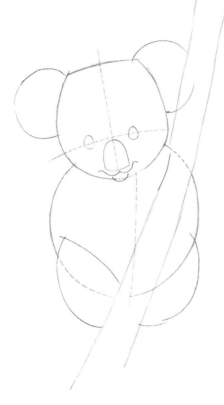

4
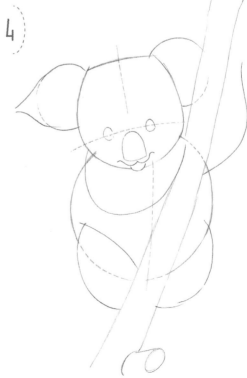

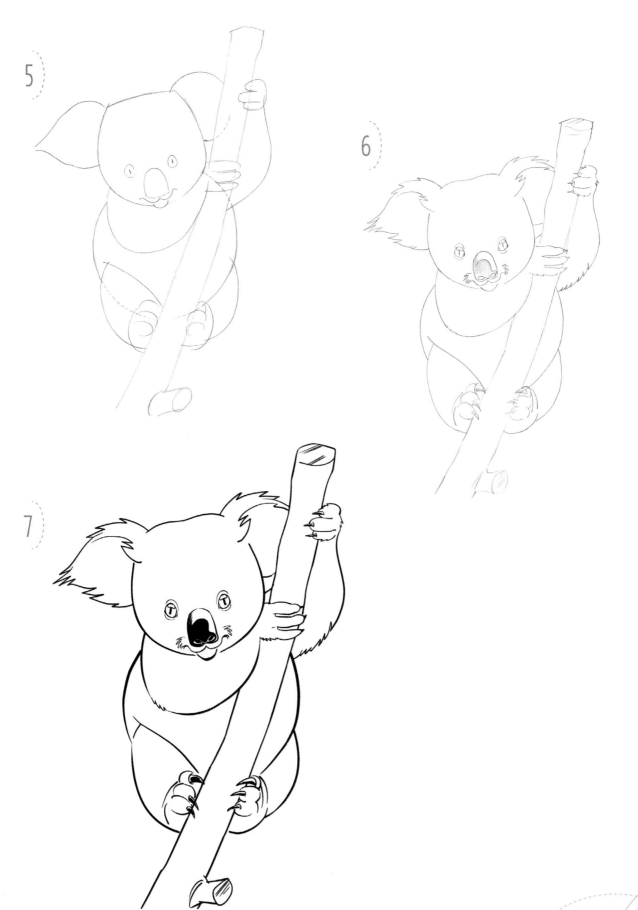

# BABY PANDA

1)

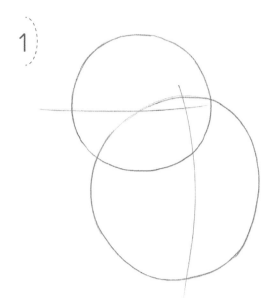

2)

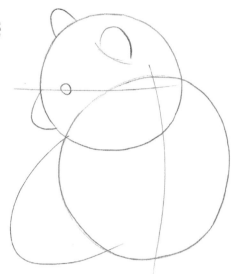

3)

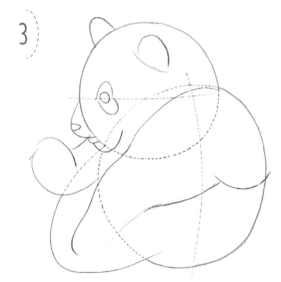

4)

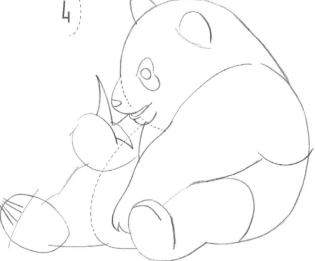

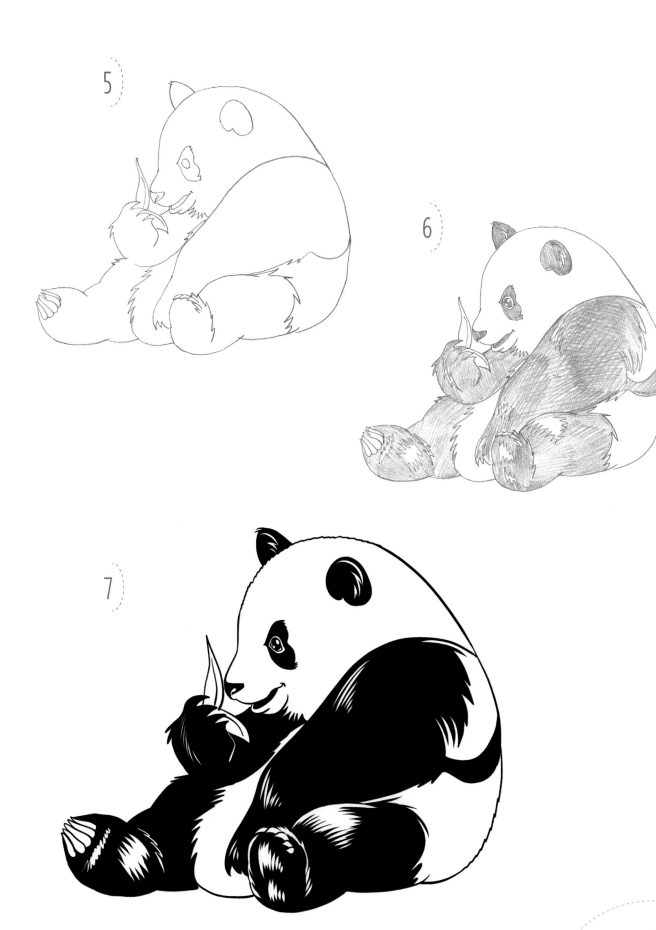

# BABY MONKEY

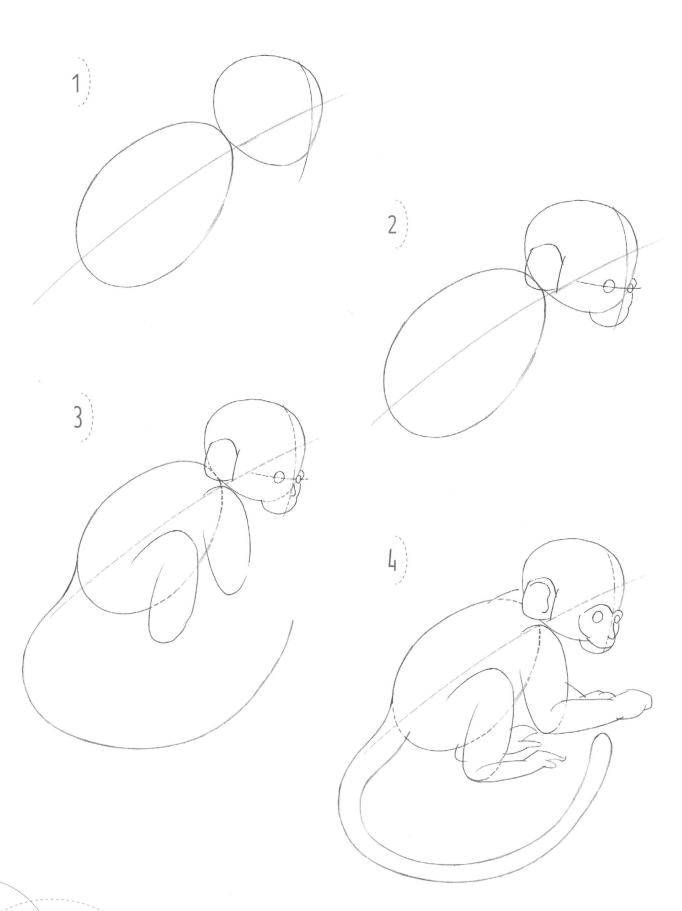

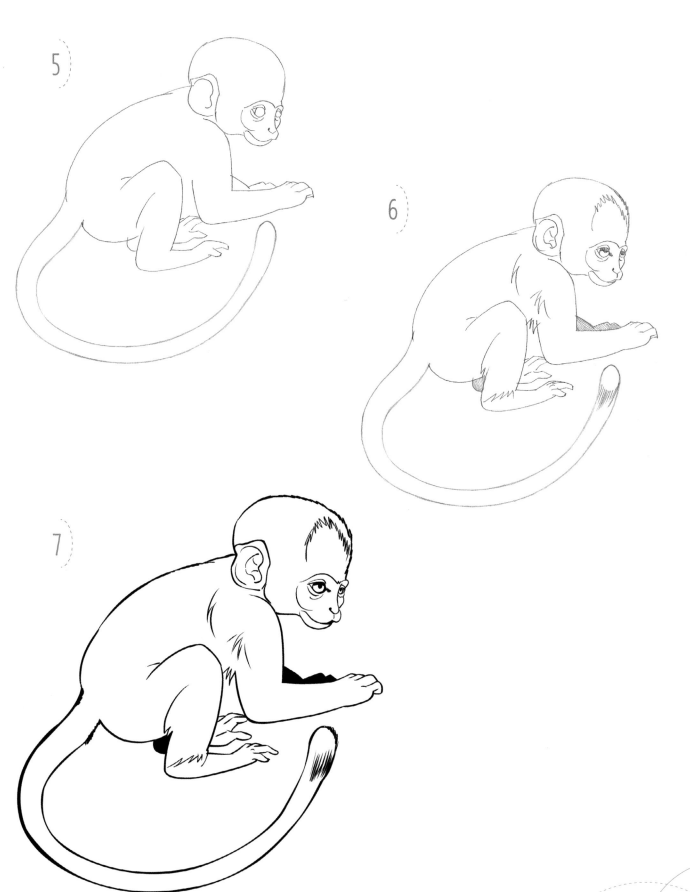

5

6

7

1

2

3

4

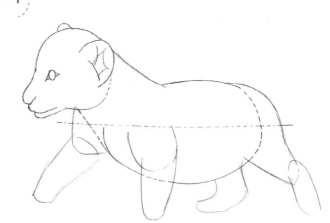

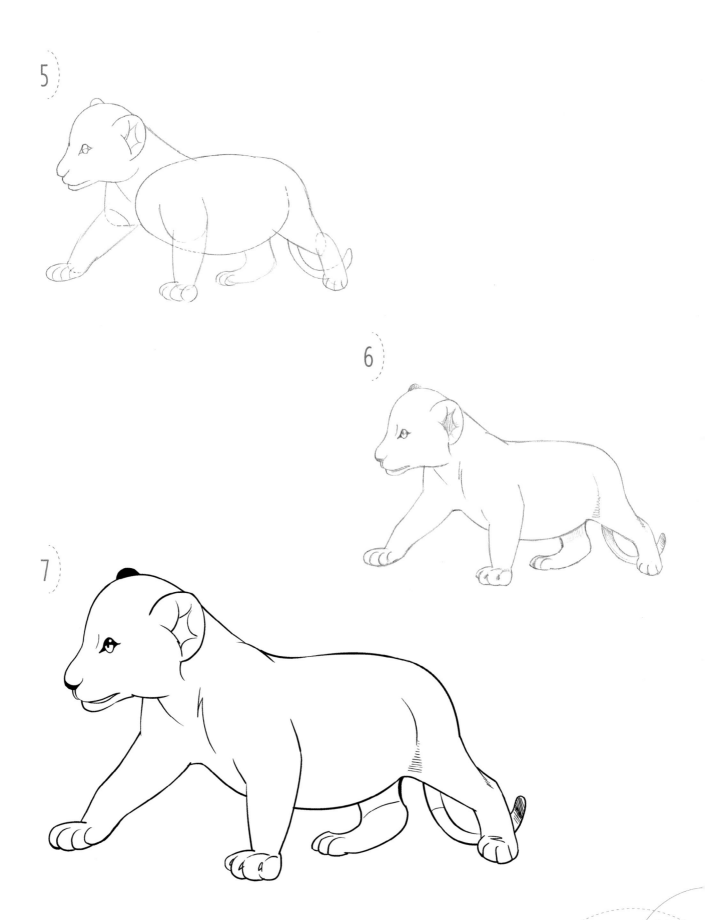

# TIGER CUB

1

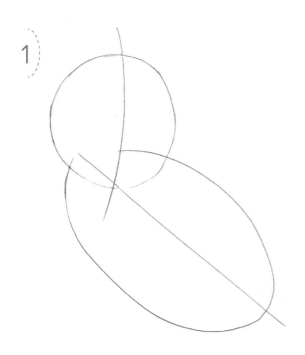

2

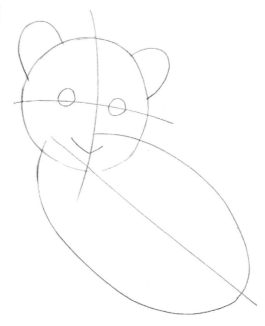

3

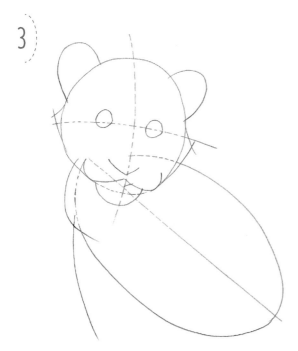

4

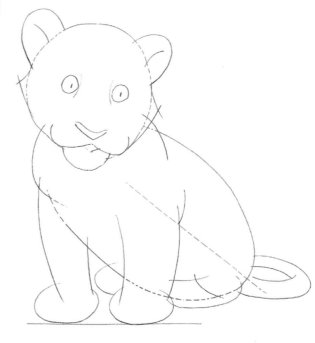

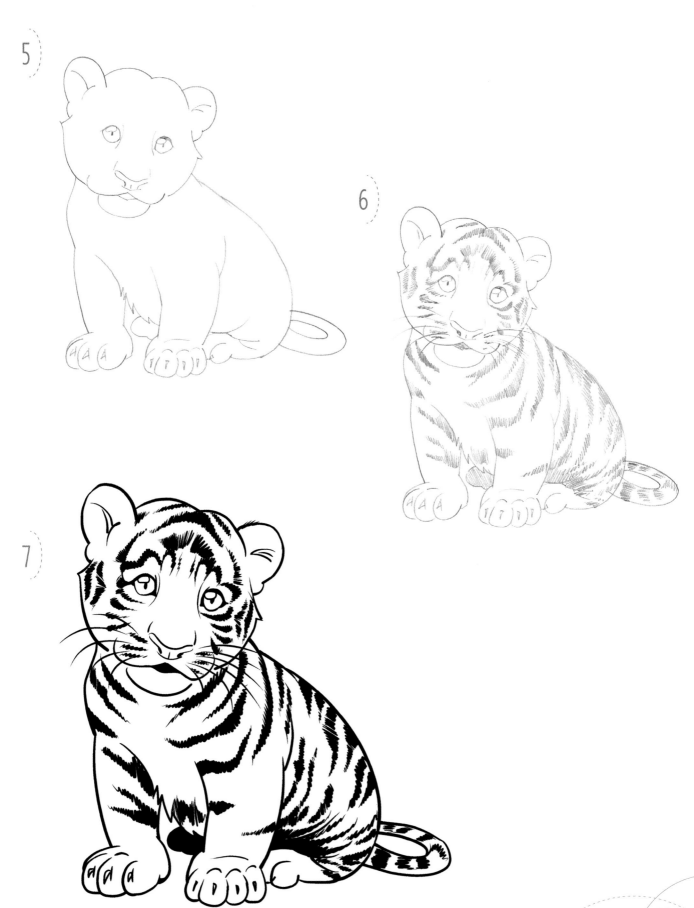

5

6

7

1

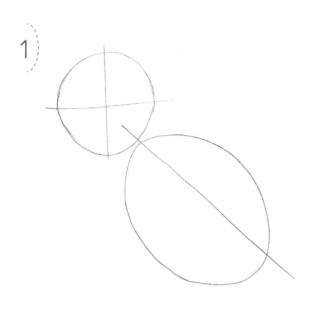

2

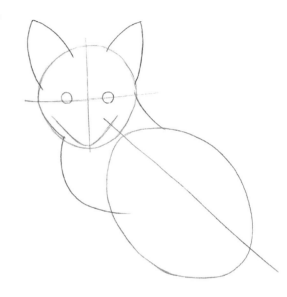

3

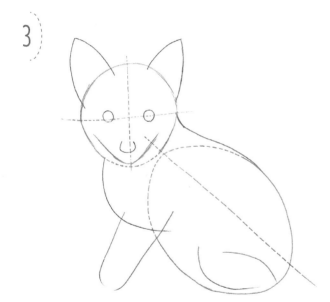

4

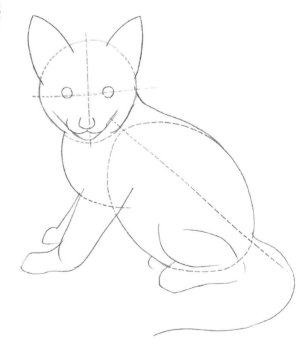

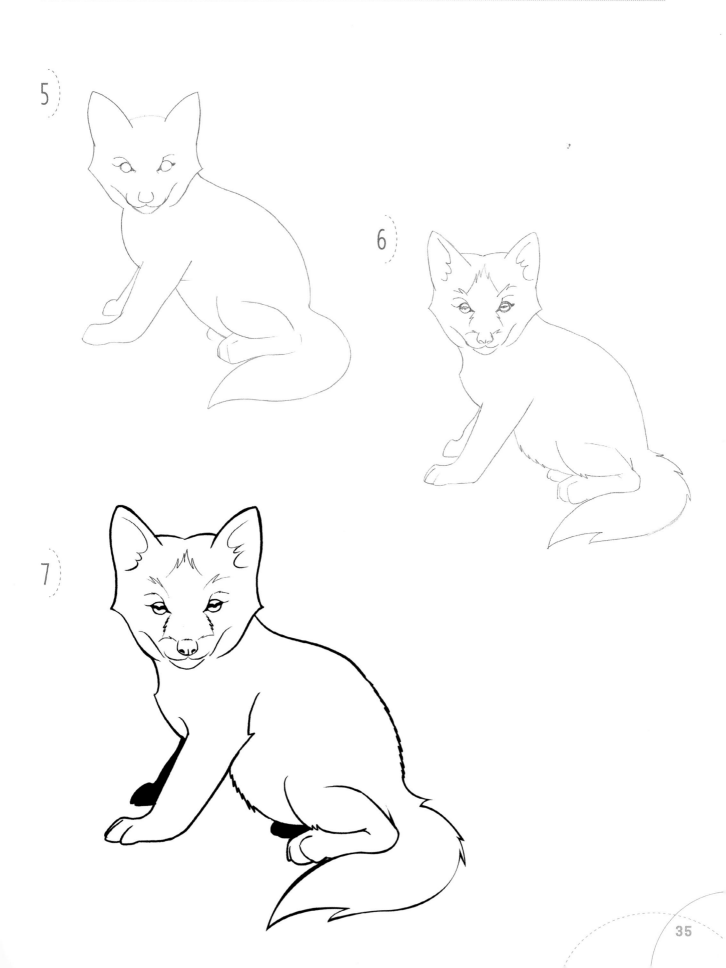

# PENGUIN CHICK

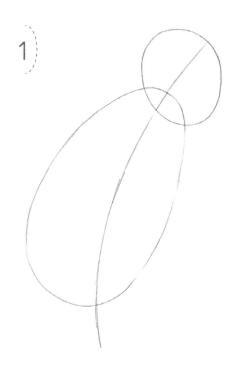

1

2

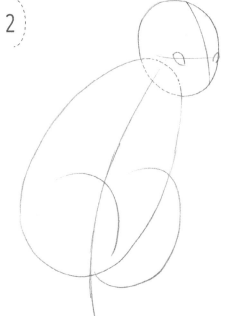

3

4

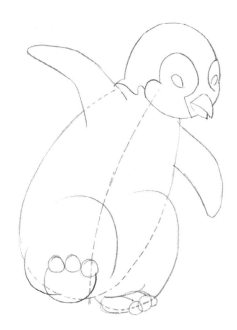

5

6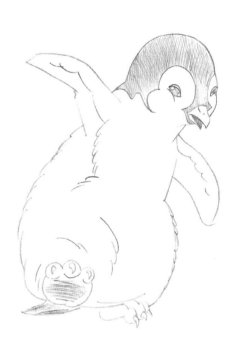

7

# BABY SEAL

1

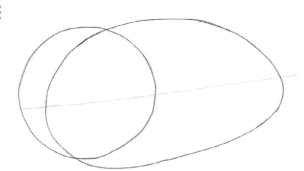
2

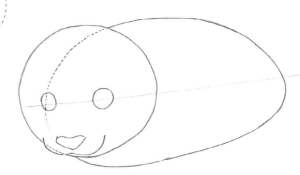
3

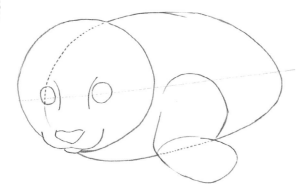
4

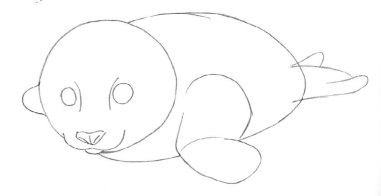

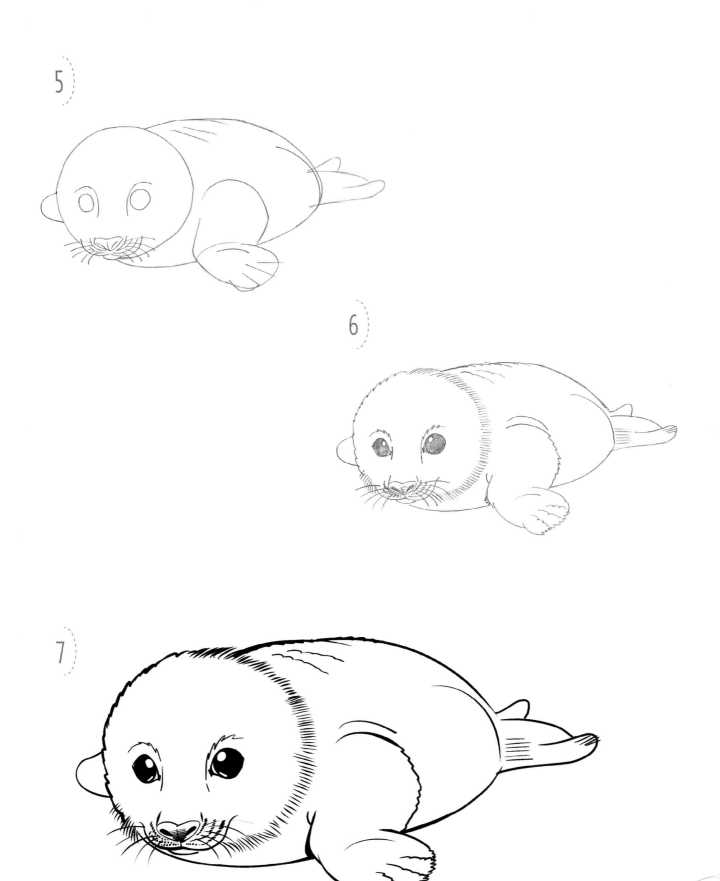

5

6

7

# DOGS

## CANINE ANATOMY

Dogs have an internal structure that determines their external shape and, incidentally, is very close to that of other mammals—including humans. You can simplify the internal structure the following way:

Compared to humans, dogs seem to have the knees of their hind legs on backwards. In fact, they are exactly like ours, only the proportions are different. Also, what looks to us like knees are actually heels!

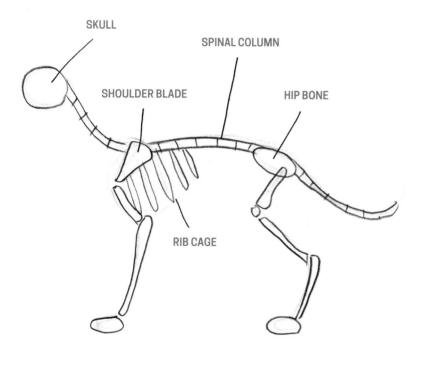

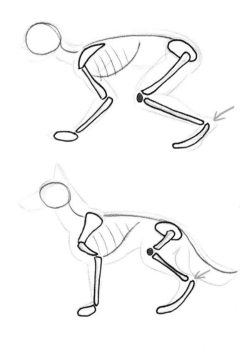

Drawing dogs is easier than it seems. First, you should observe them in order to identify the simple geometric shapes that make them up.

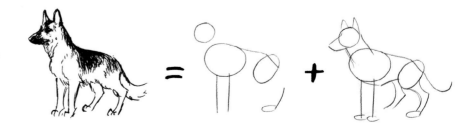

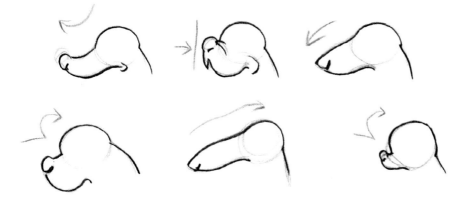

Carefully observe the form of the muzzle: Is the line that links it to the skull soft? Is the muzzle flat, concave, or convex? Long, fine or thick?

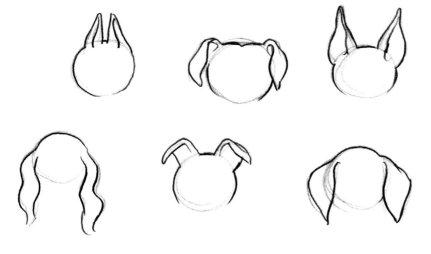

It is equally important to look at the ears. Are they far apart or close? Are they large, pointed, or shaggy? Are they situated on the top of the head or on the sides?

And the tail—what is it like? Is it short, long, shaggy, high, low or docked?

Now observe the dog's back. Is it horizontal, sloped, concave or convex?

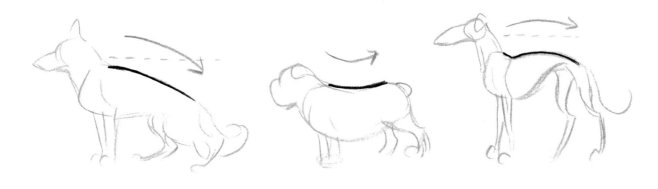

Practice drawing the dog's expression. Examine it closely and compare it to that of a human. Is it sad? Is it angry? Does the dog seem intelligent or lazy?

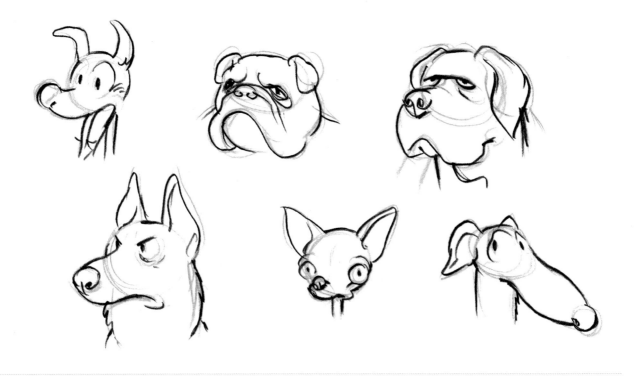

When a dog walks, its front legs move inverse to the back legs, and the right legs move inverse to the left.

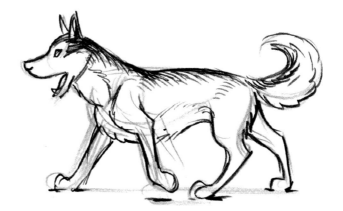

Beginning with simple shapes, it is easy to draw a dog from any point of view. Only after drawing the silhouette can you add the details.

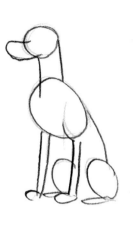
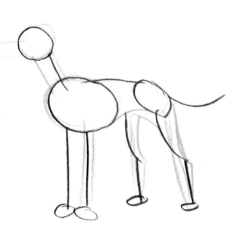
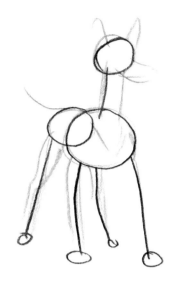

When you draw the coat, follow the direction of the body shape. The result will only look better.

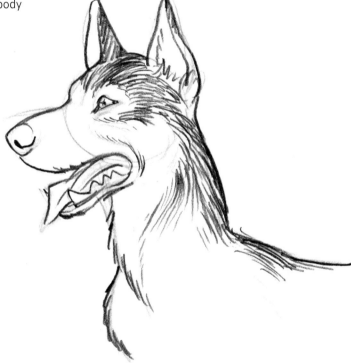

The more you draw dogs, the better you will get.

*THAT'S ENOUGH THEORY.*
*LET'S MOVE ONTO THE PRACTICAL!*

43

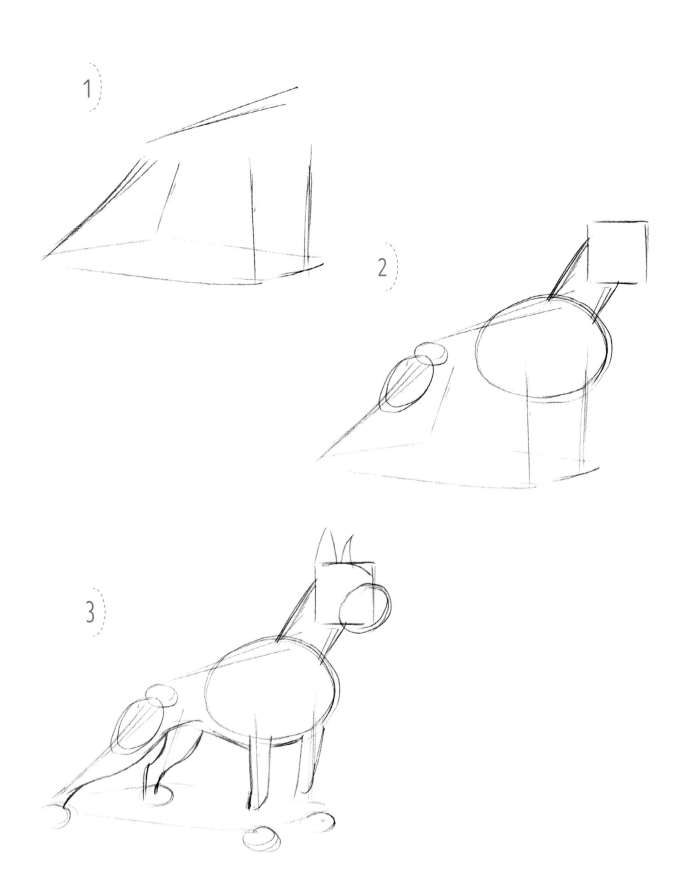

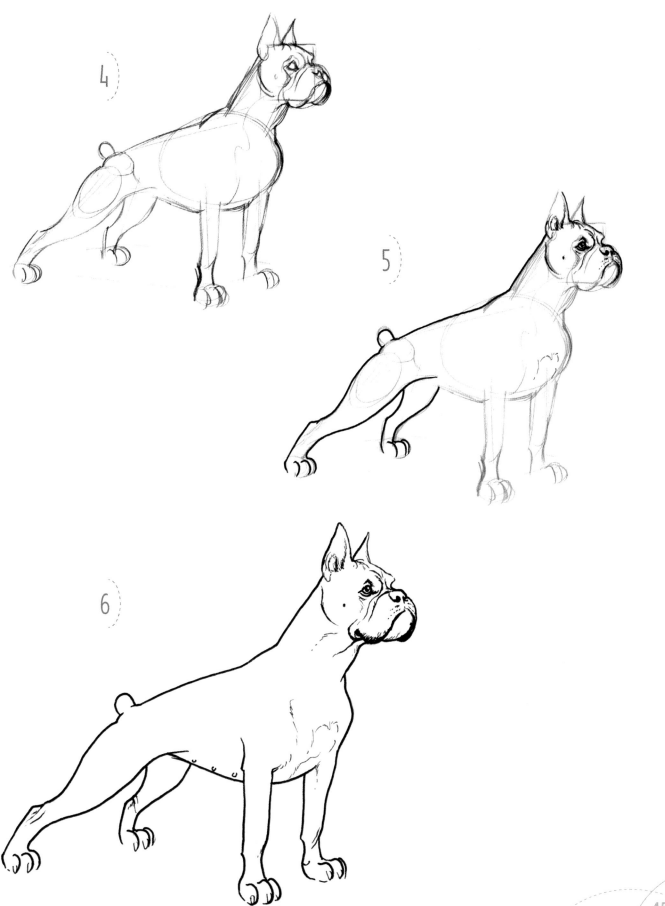

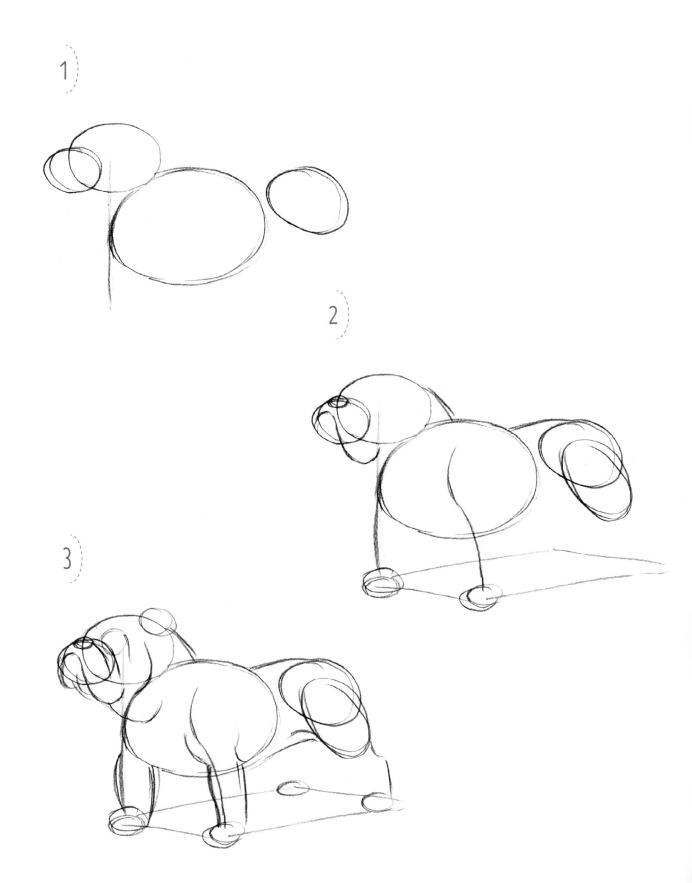

1

2

3

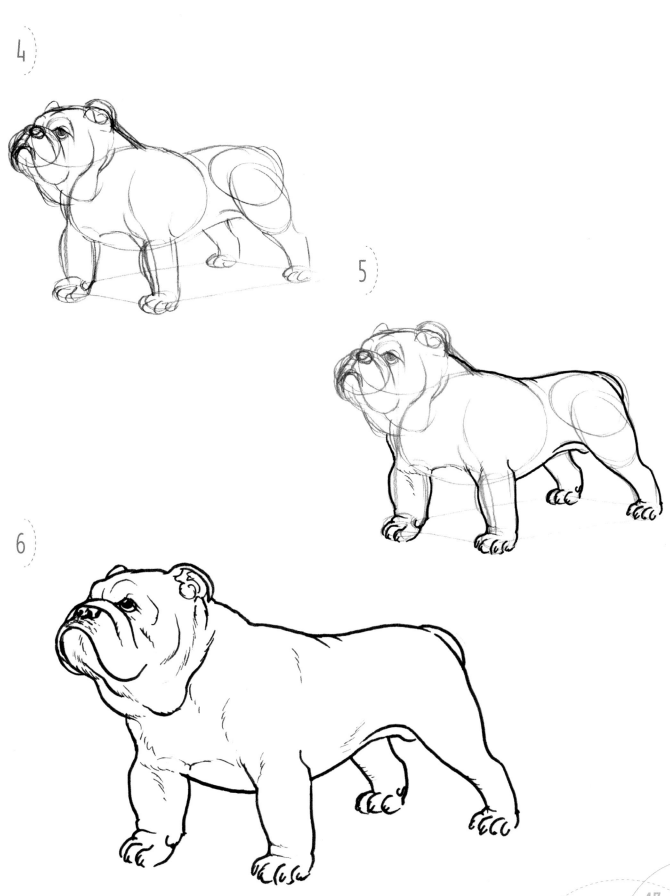

4

5

6

1

2

3

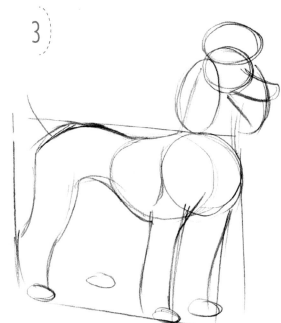

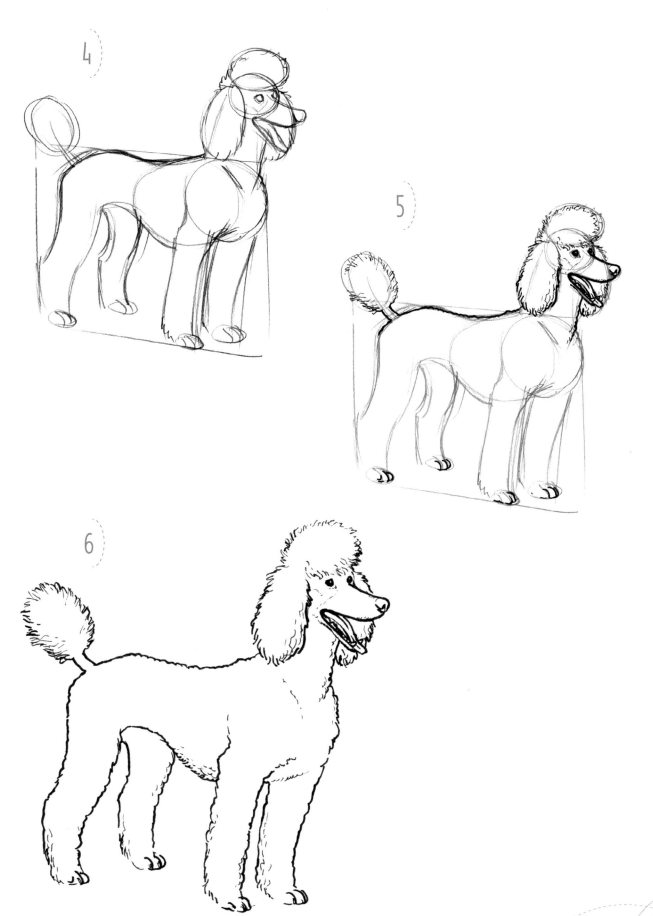

4

5

6

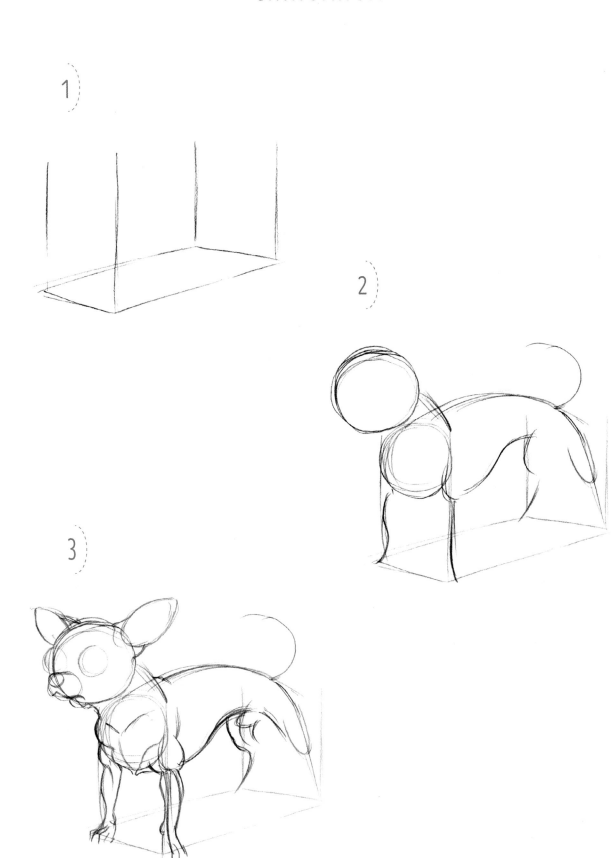

1

2

3

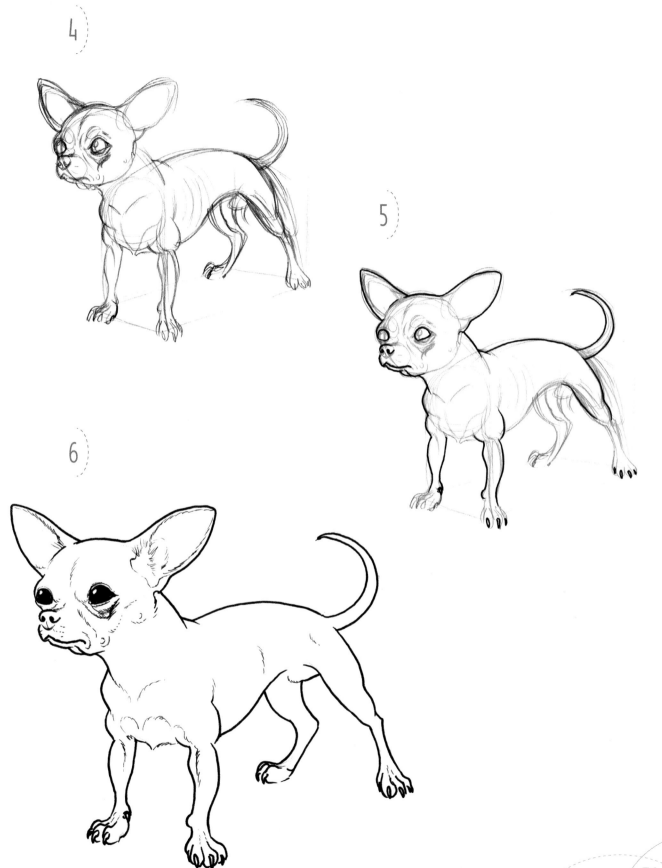

1

2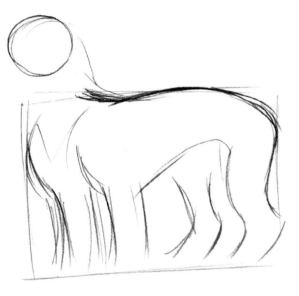

3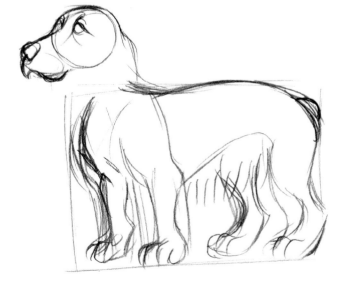

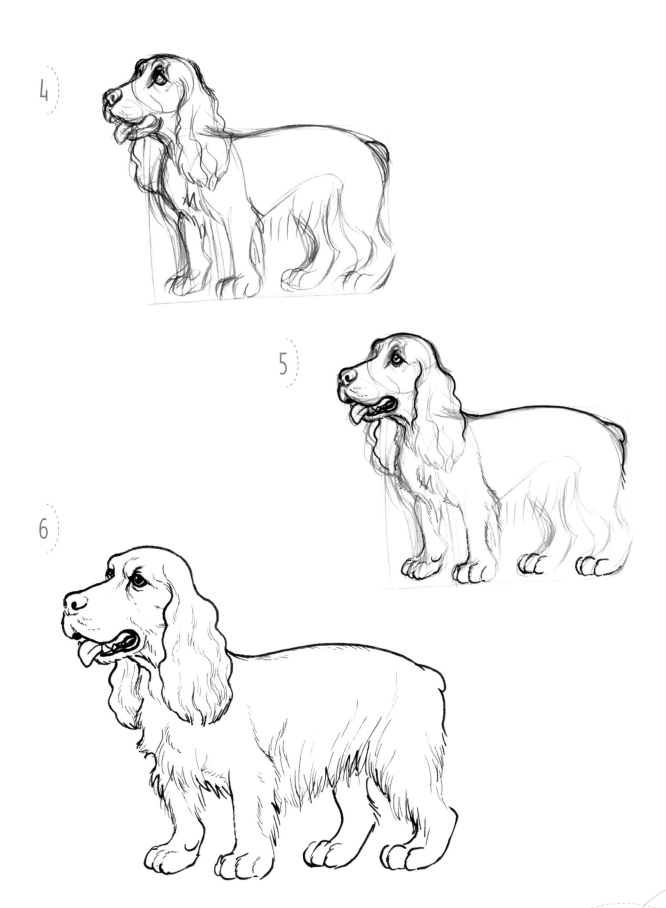

4

5

6

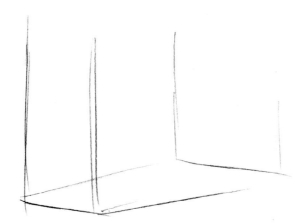

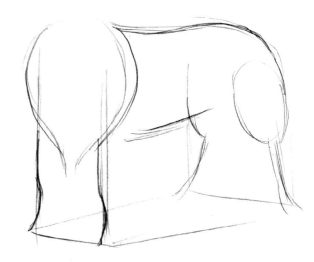

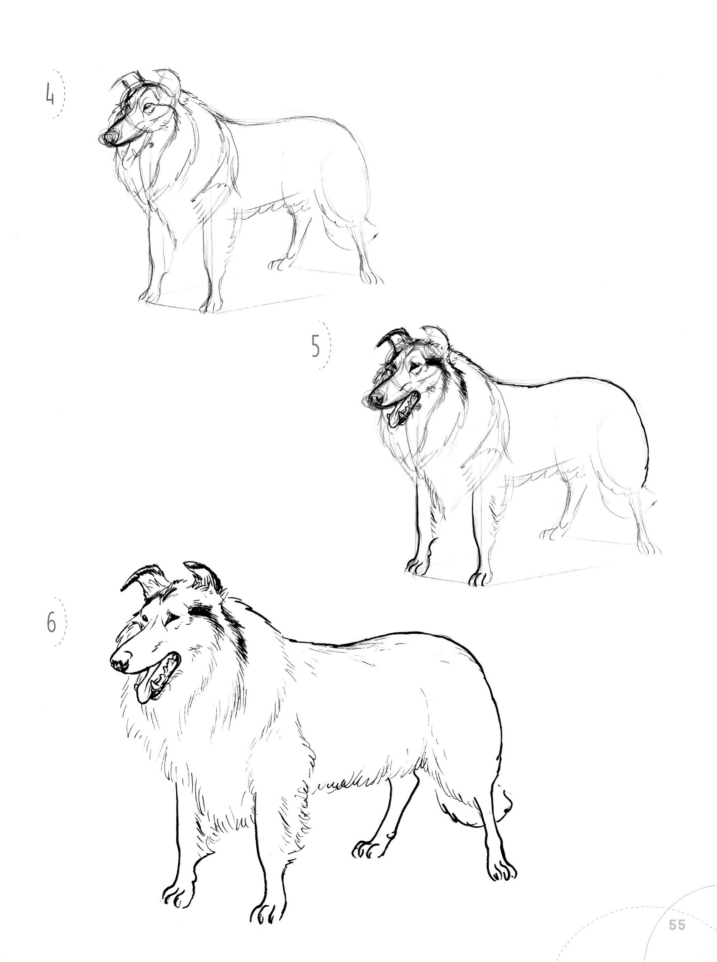

1

2

3

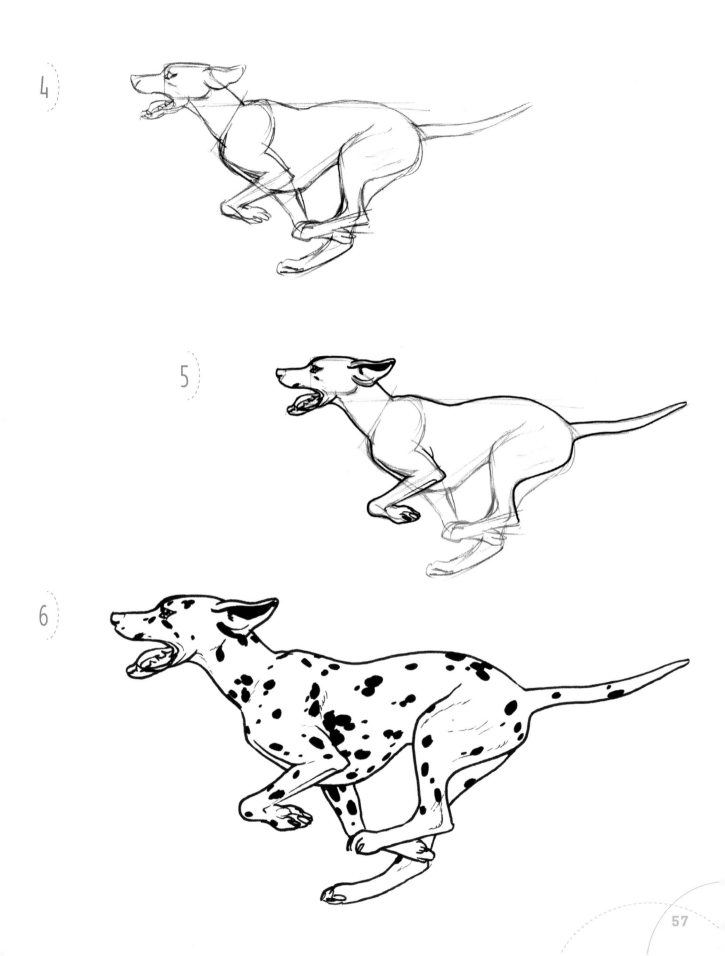

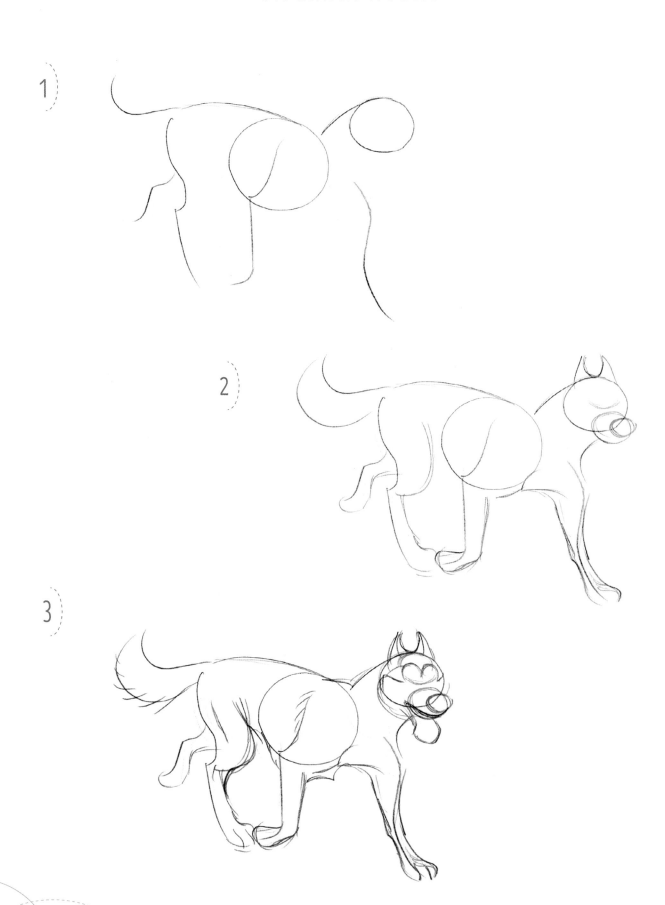

1

2

3

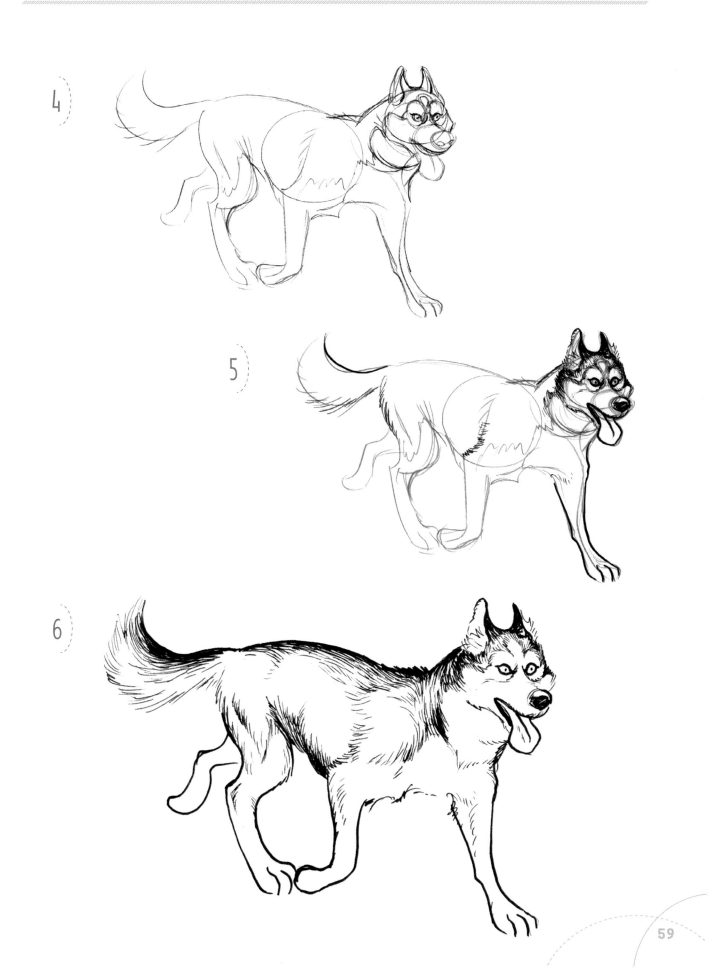

# GERMAN SHEPHERD

1

2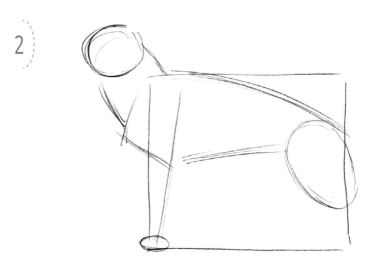

3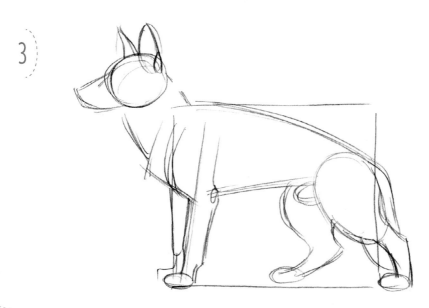

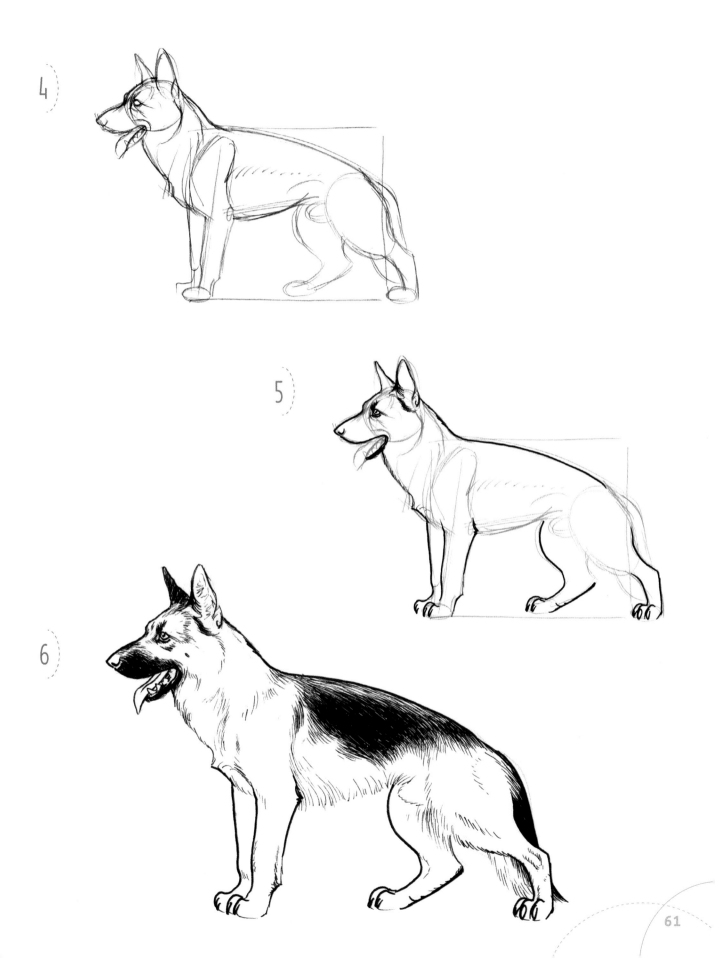

1

2

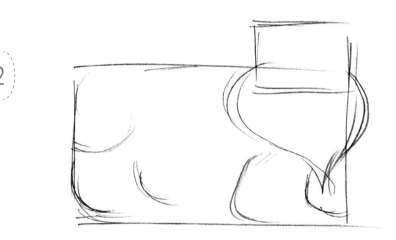

3

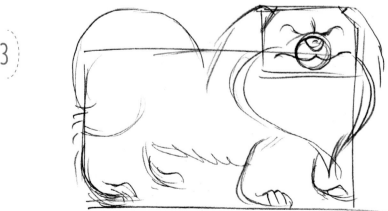

4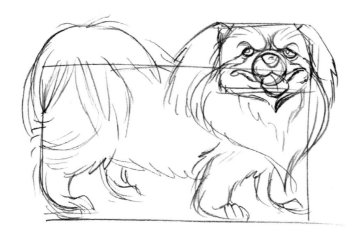

5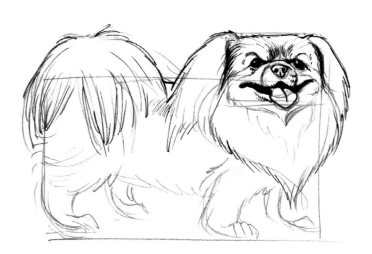

6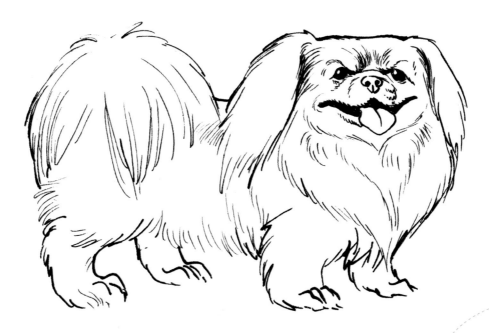

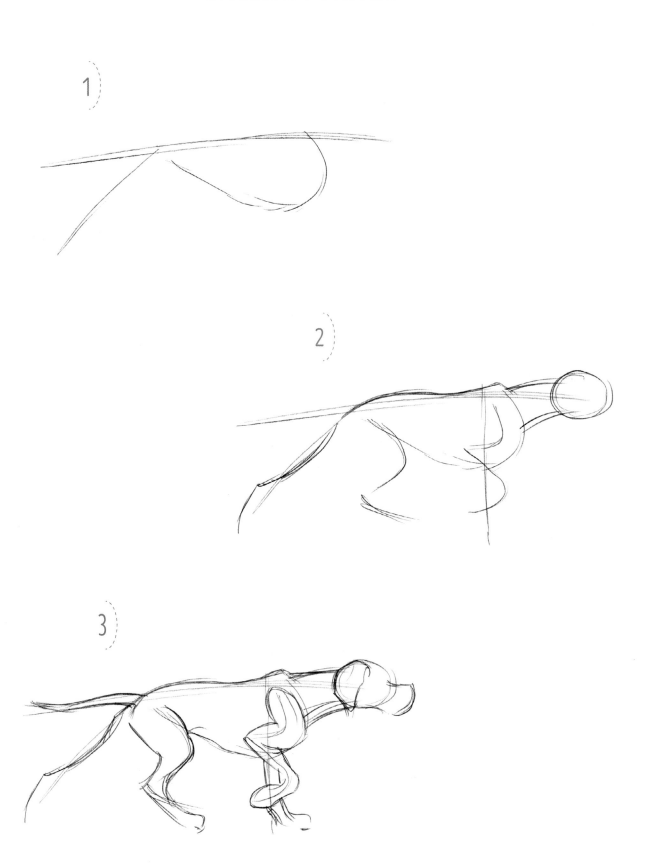

1

2

3

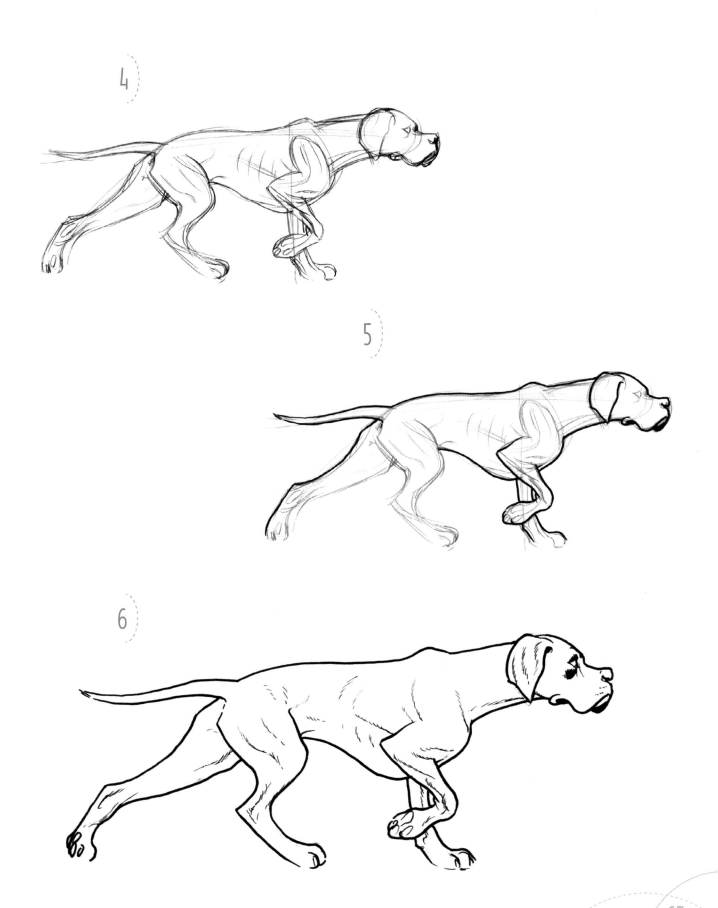

# SAINT BERNARD

1

2
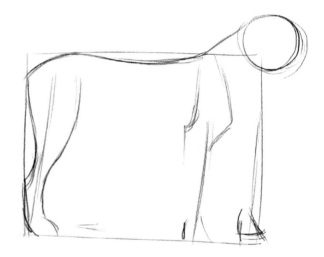

3
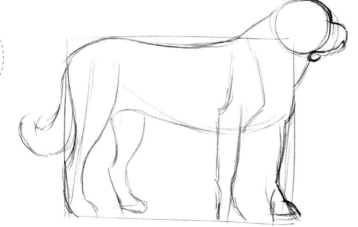

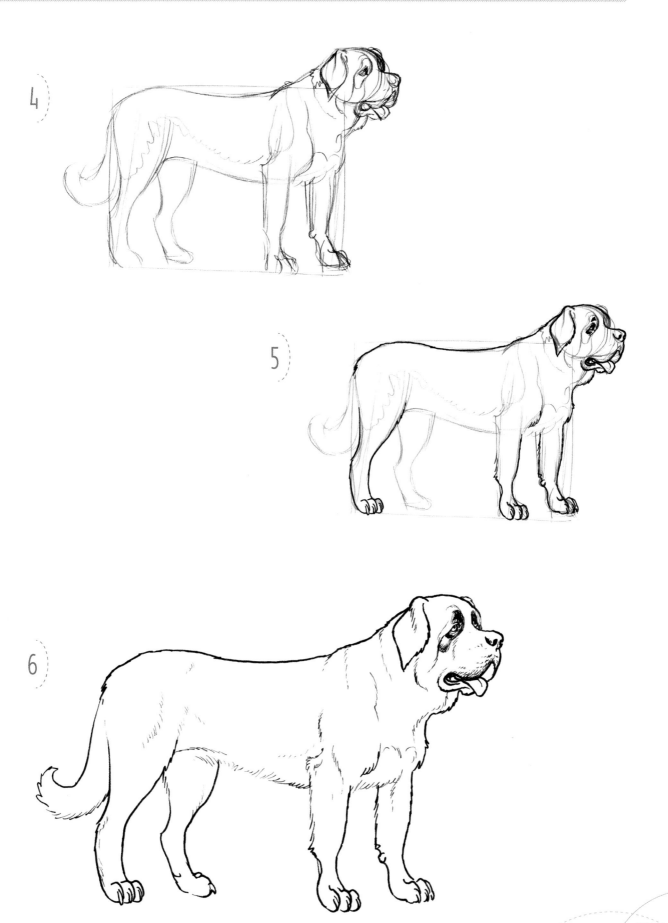

1

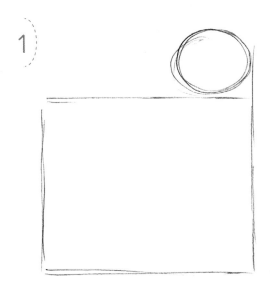

2

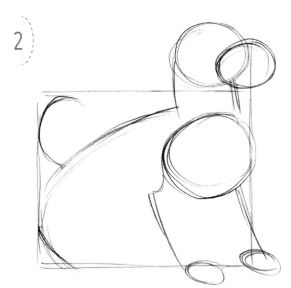

3

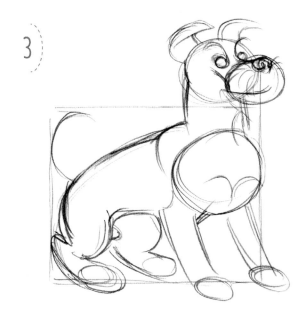

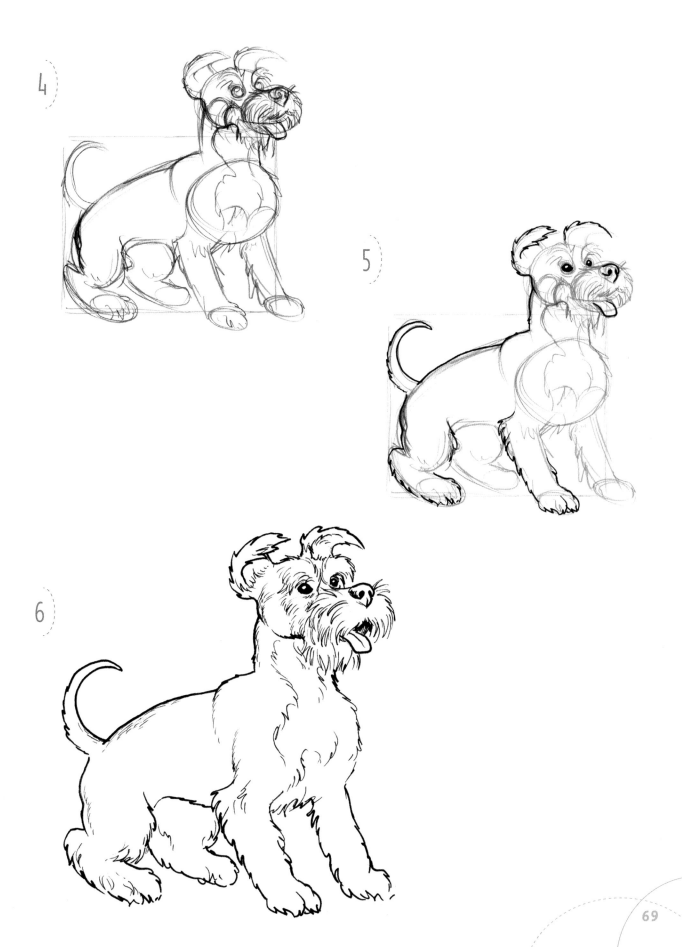

1

2

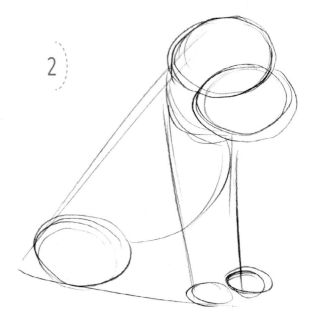

3

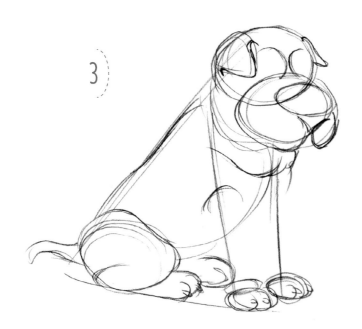

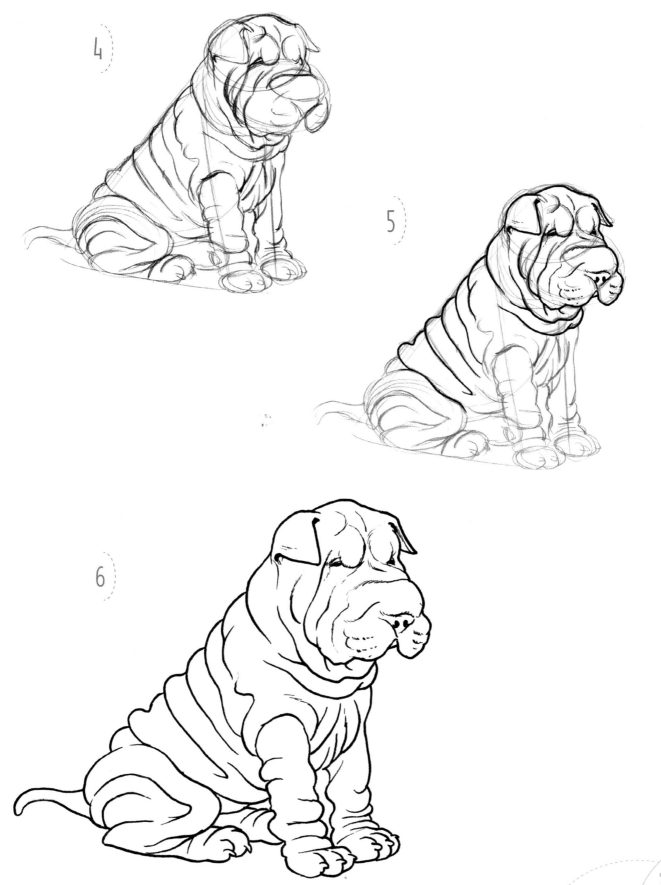

1)

2)

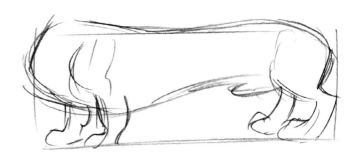

3)

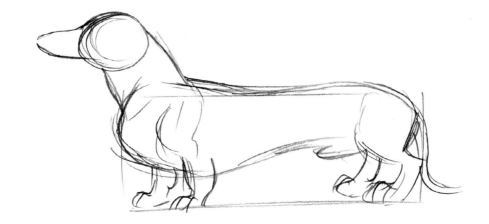

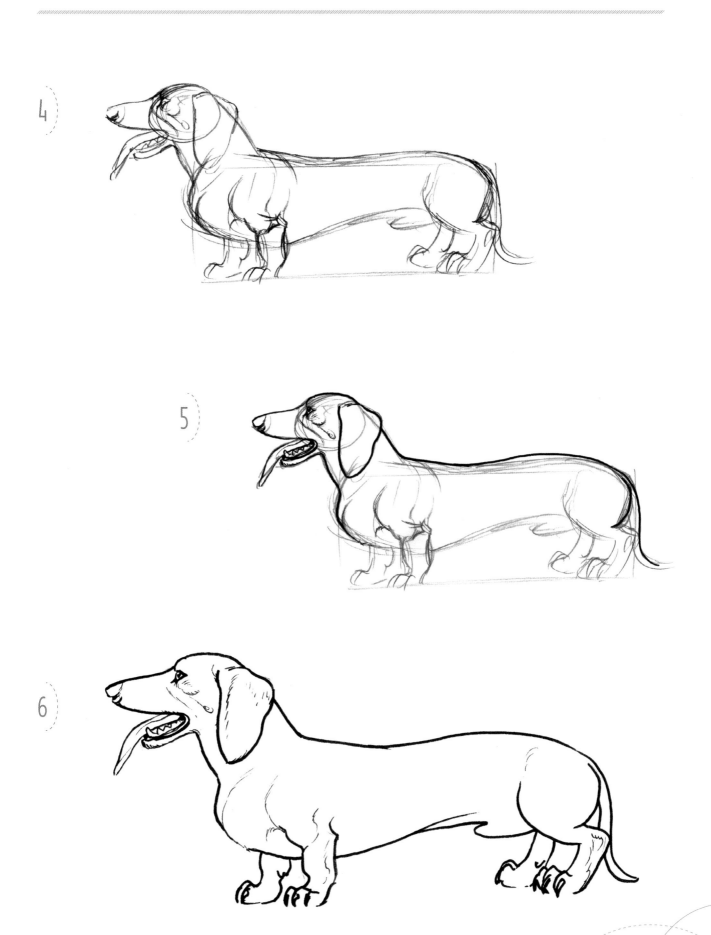

4

5

6

# FARM ANIMALS

## HEN AND CHICKS

1) Begin with oval shapes for the bodies.

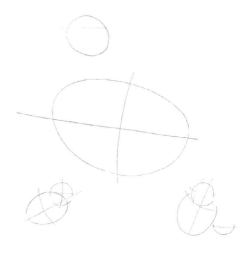

2) Add smaller circles for the heads.

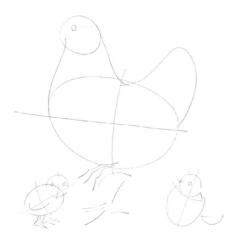

3) Build the general shapes and begin to draw the legs.

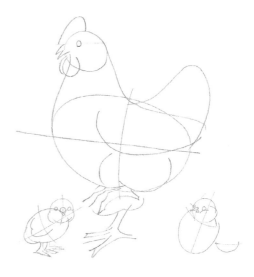

4) Add the beaks and eyes as well as the wings.

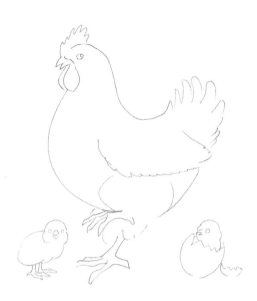

5 ) Clean up the structural lines and add details.

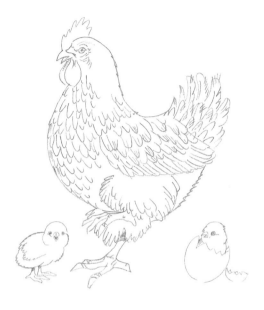

6 ) Finalize the pencil drawing.

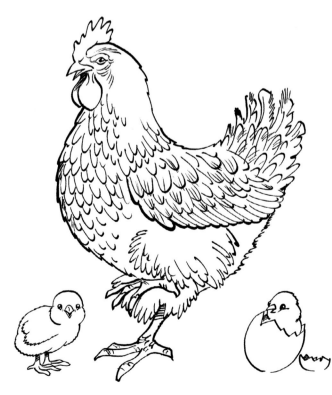

7 ) Ink the piece with a felt-tip pen or a brush with India ink.

1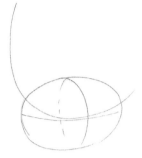

2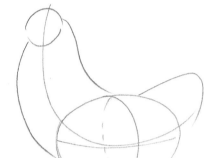

3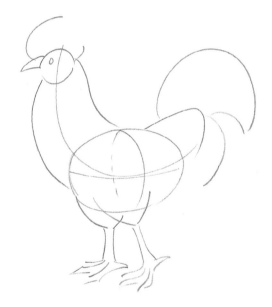

4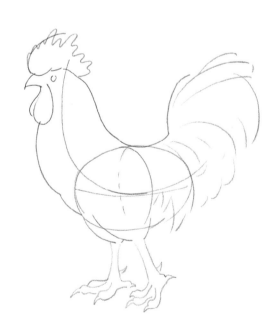

5

6

7

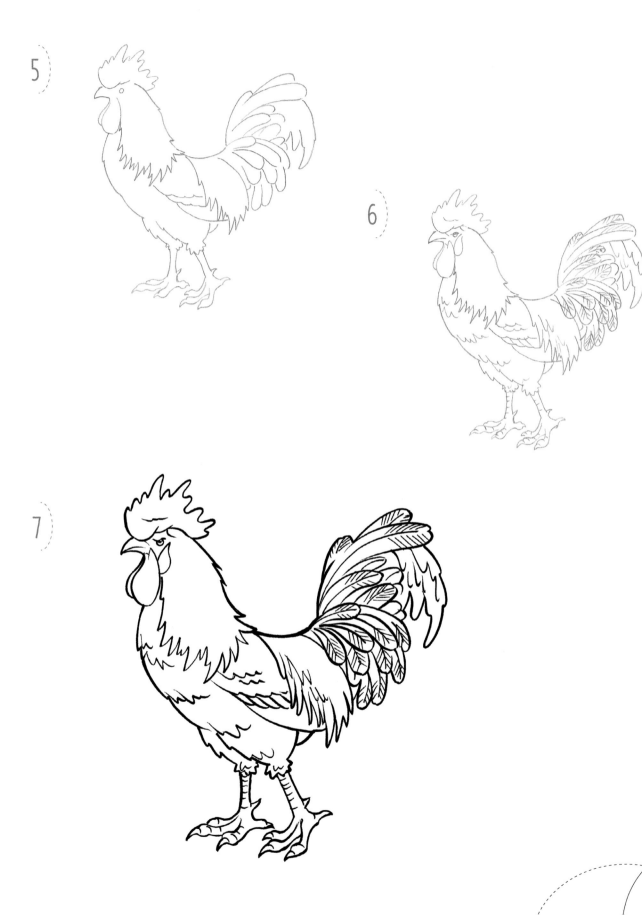

1

2

3

4

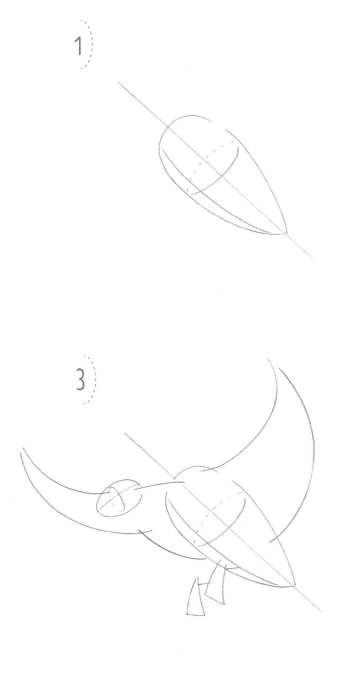

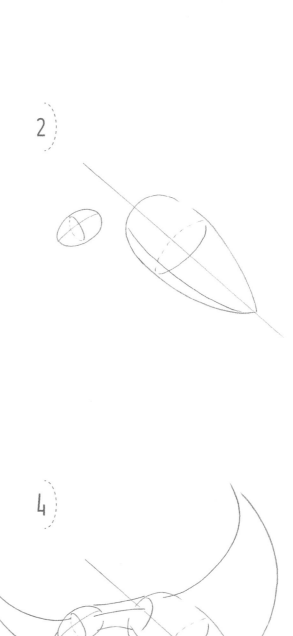

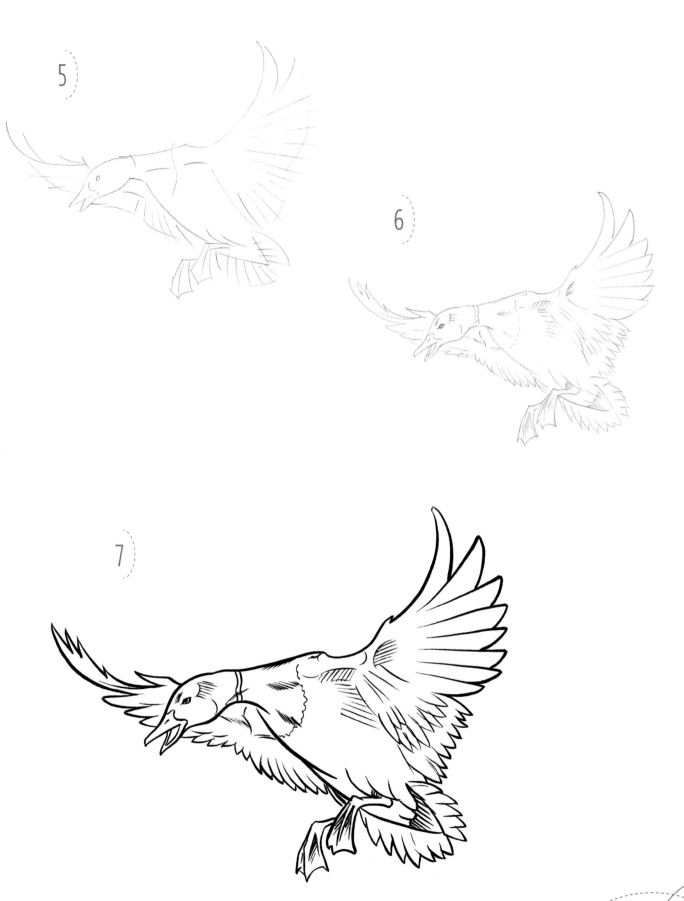

5

6

7

# PIG

1

2
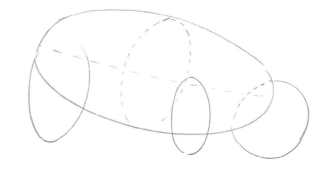

3
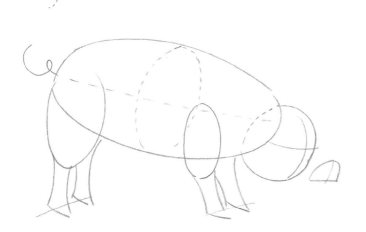

4
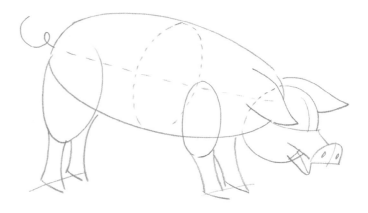

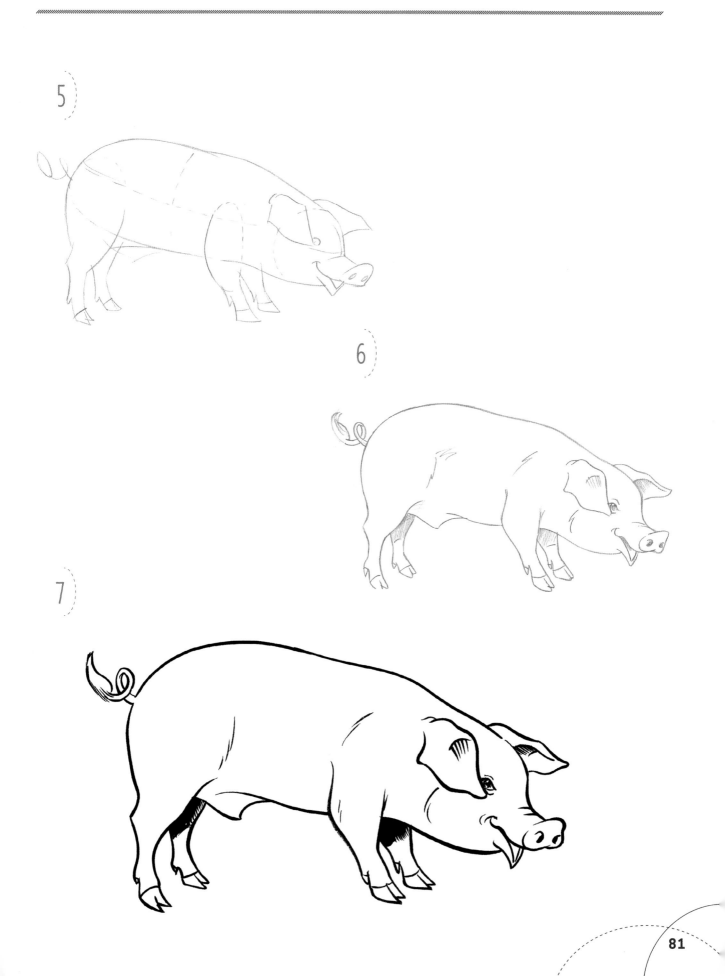

5

6

7

# GOAT

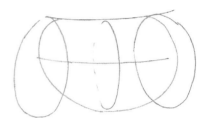

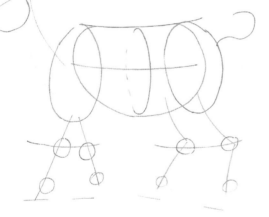

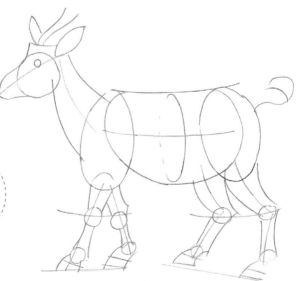

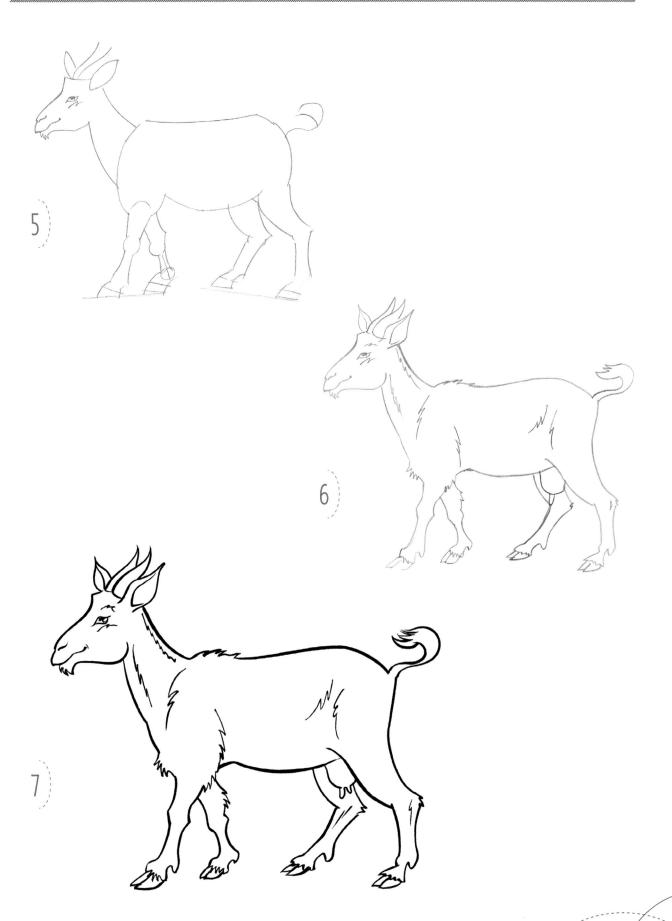

5

6

7

# STEER

1

2

3
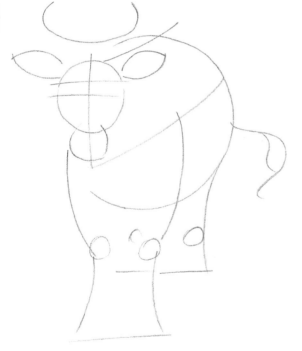

4
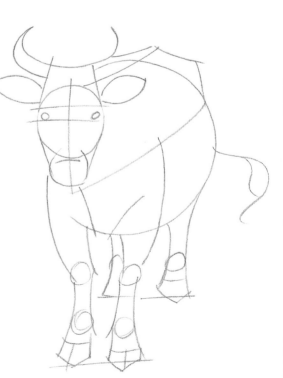

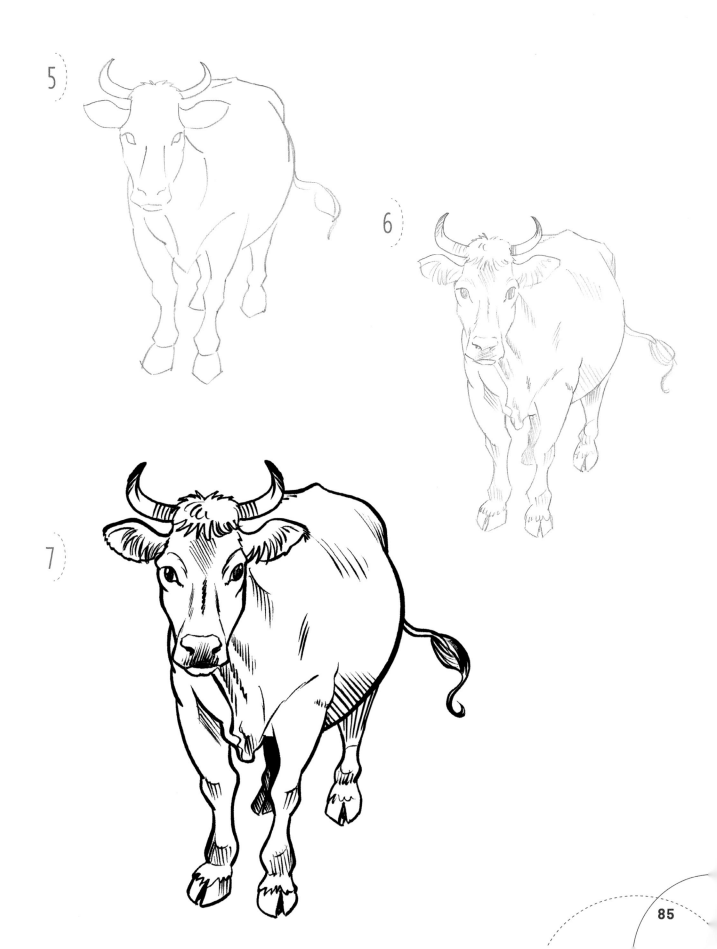

# PONY

1

2

3

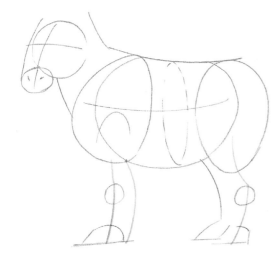

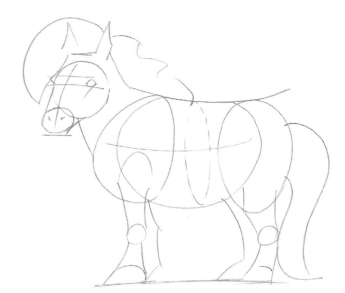

4

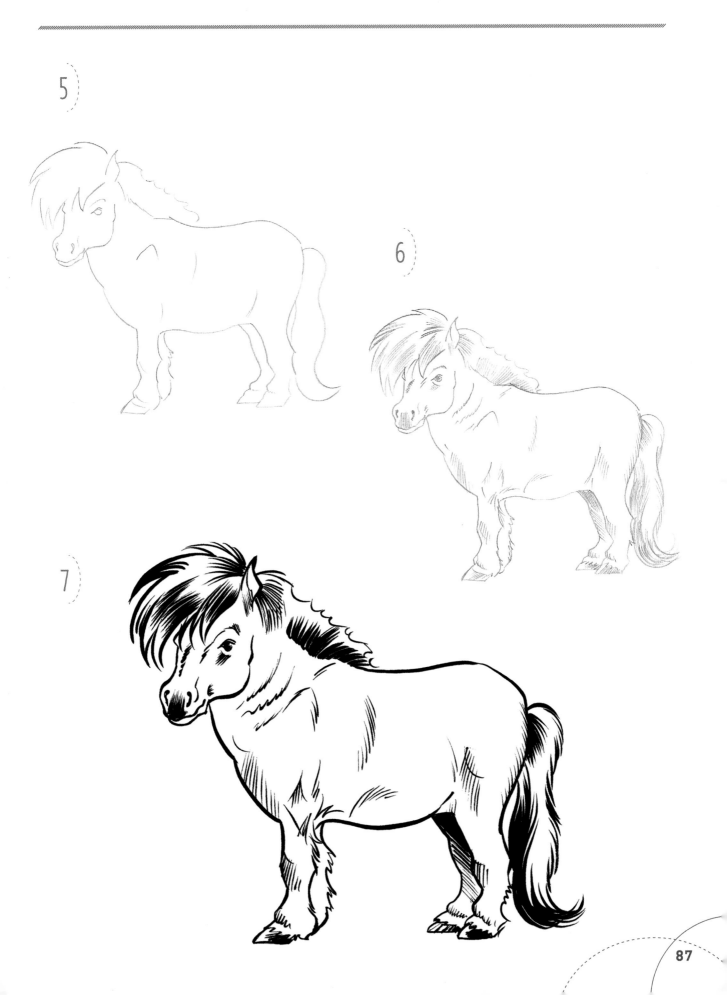

5

6

7

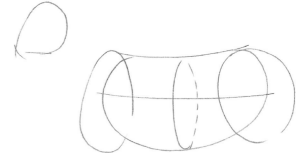

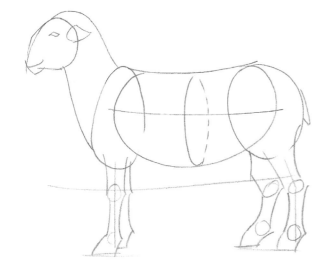

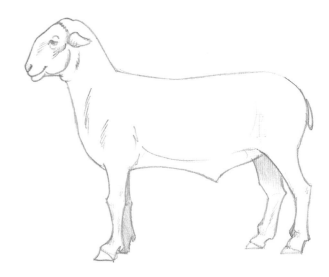

5

6

7

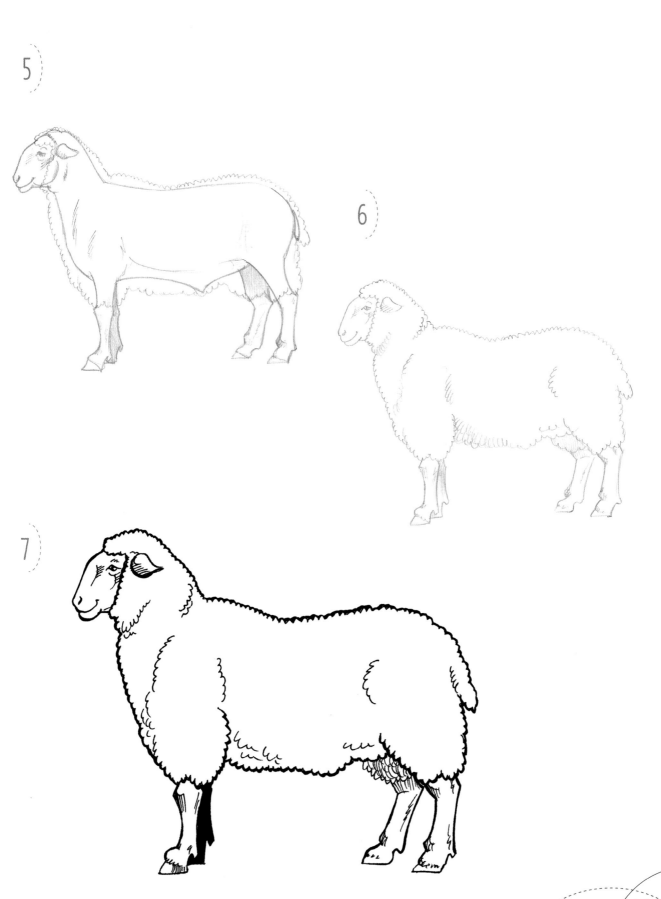

1

2

3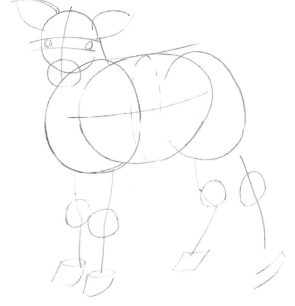

4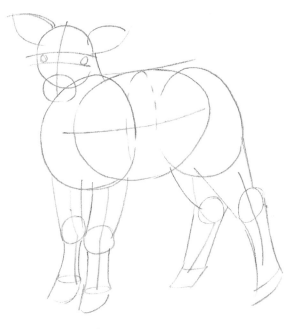

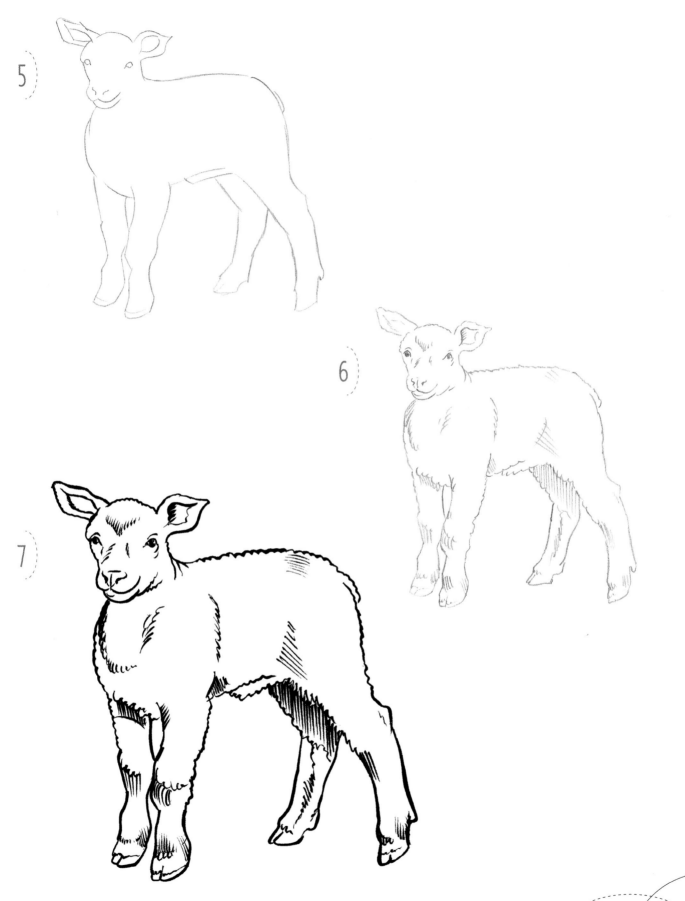

5

6

7

# HORSES

## ANATOMY

Drawing a horse is very difficult due to the complexity of its anatomy. In order to simplify this design, you will work in large groups. Note the spinal cord, which starts at the top of the head and ends at the tail, and defines the horse's posture.

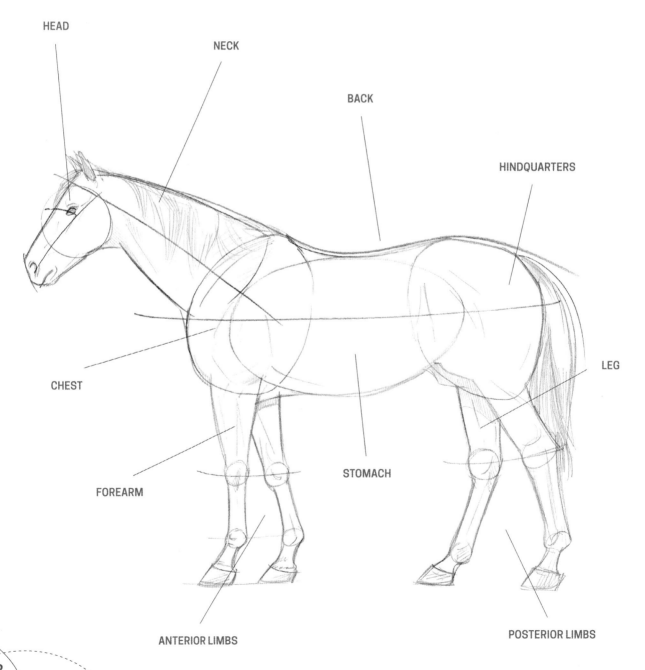

HEAD

NECK

BACK

HINDQUARTERS

CHEST

LEG

FOREARM

STOMACH

ANTERIOR LIMBS

POSTERIOR LIMBS

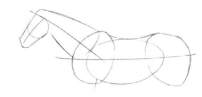

1. Draw an oval shape for the stomach. Then place the head (a circle) and the guideline for the neck and the slope of the back.

2. Add the chest and the hindquarters.

3. Sketch the muzzle and the neck.

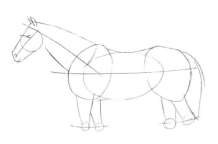

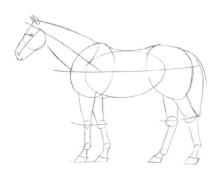

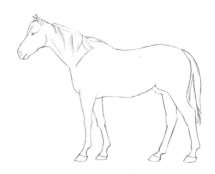

4. Add the eyes, the ears and the nostrils. Sketch the tail and begin to draw the legs and the forearms.

5. Continue drawing the posterior and anterior limbs as well as the hooves.

6. Erase the structural lines and then sketch the mane.

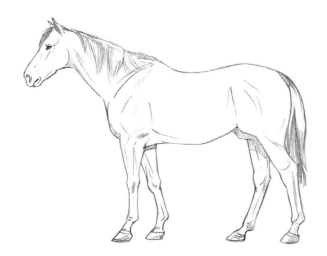

7. Finalize the details.

# A HEAD FROM ALL ANGLES

To draw the horse's head, begin with a circle that includes the eyes and the cheeks. Next, trace a triangular shape in line with the cheeks to make the muzzle, and then another, flattened shape for the forehead. Position the ears and eyes, then the nostrils and mouth. Don't forget to add the mane and the lock of hair that falls down the forehead!

THE FACE

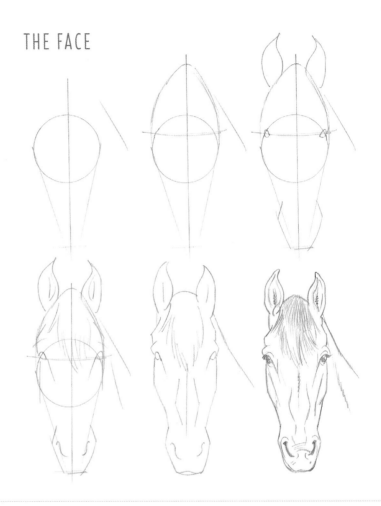

PROFILE

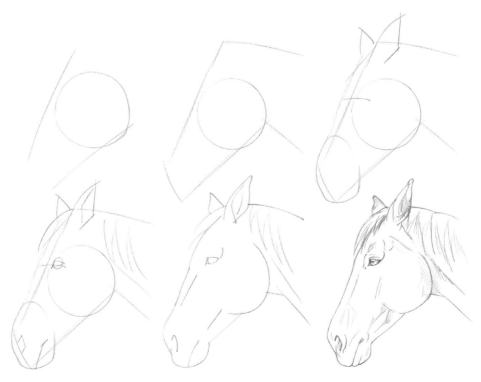

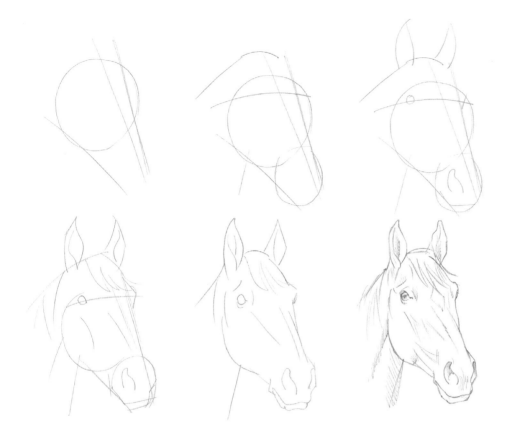

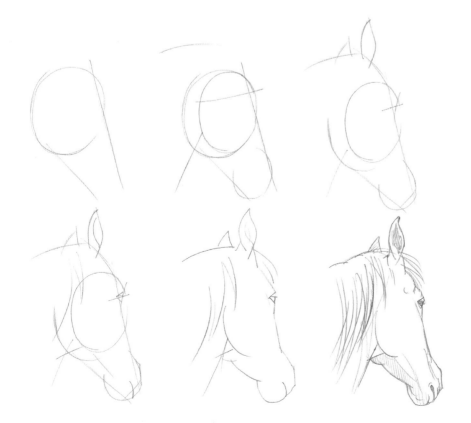

1

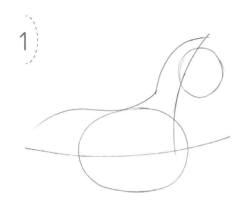

2

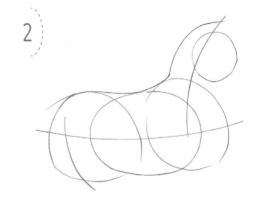

3

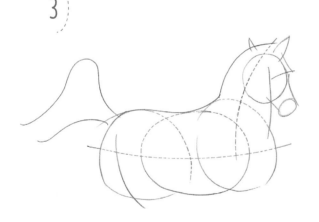

4

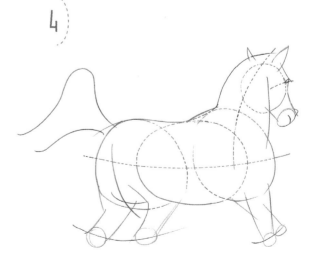

5

6

7

8

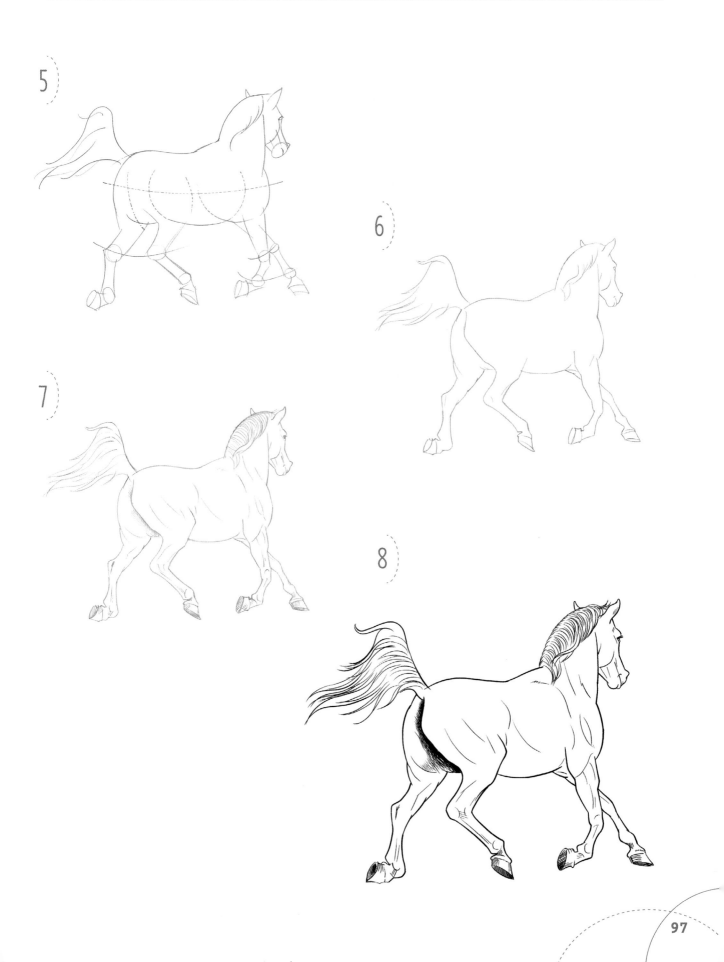

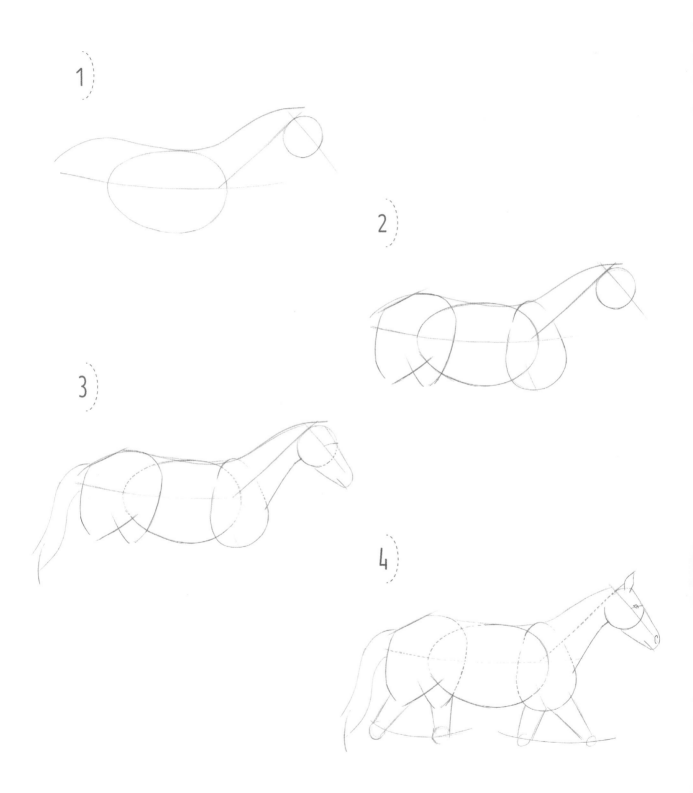

5

6

7

8

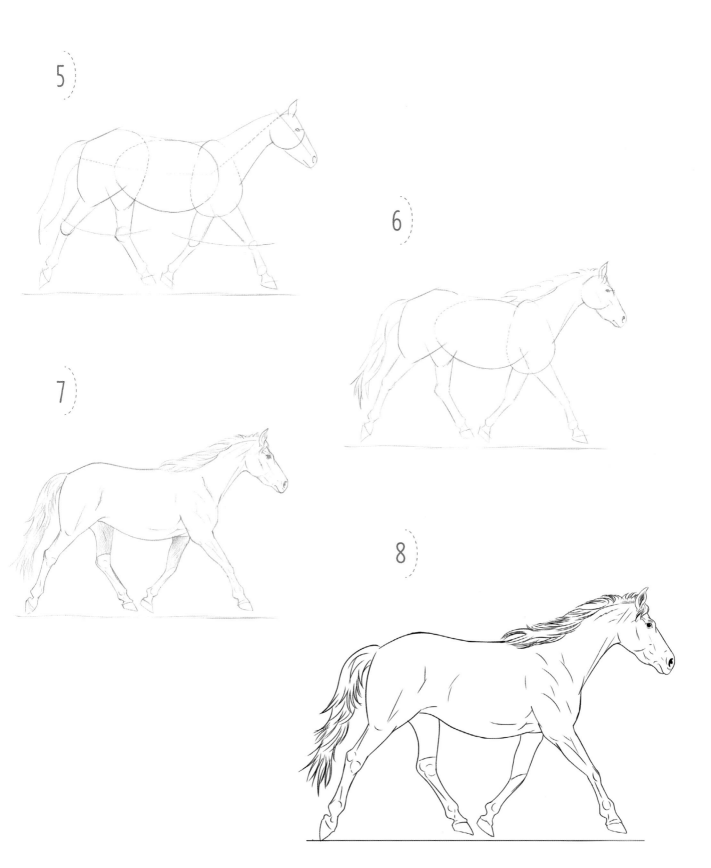

# GALLOPING HORSE

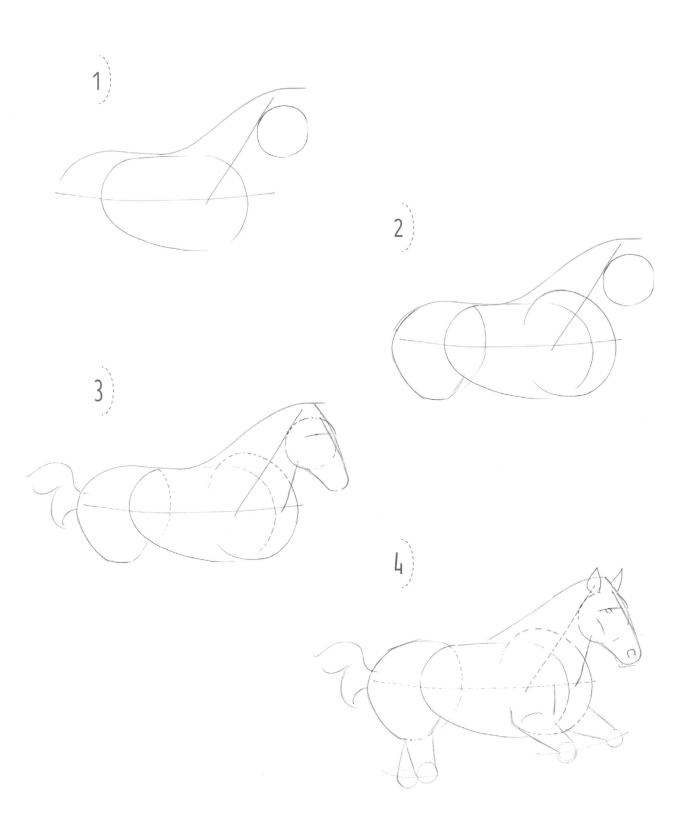

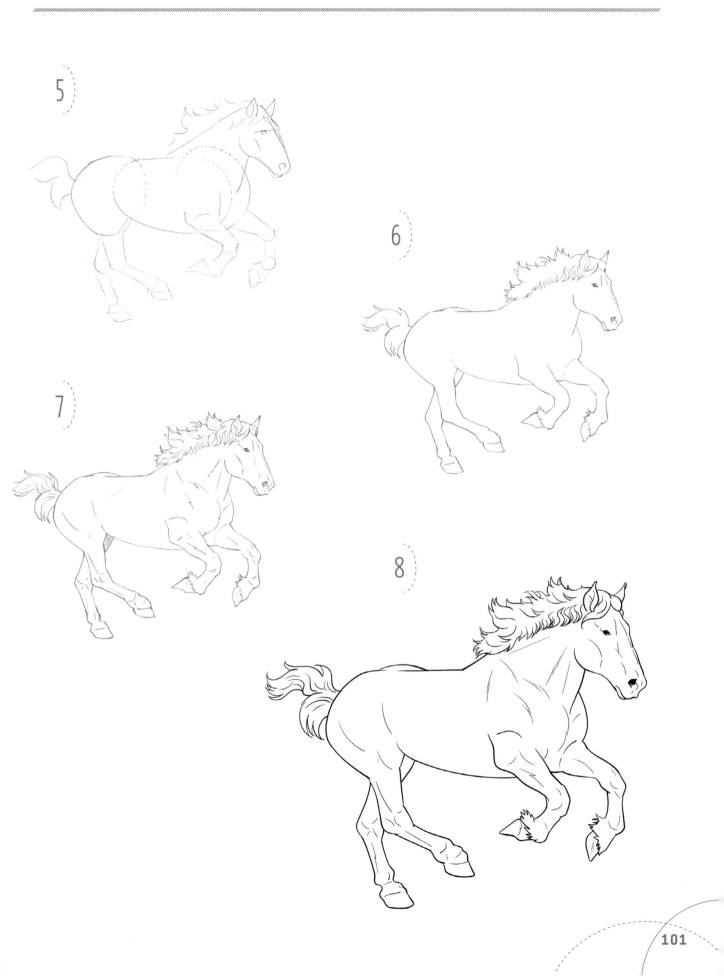

5

6

7

8

1

2

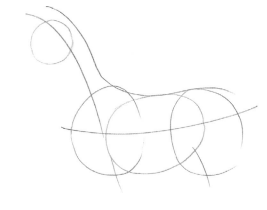

3

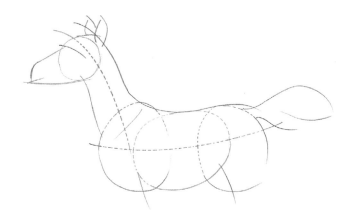

4

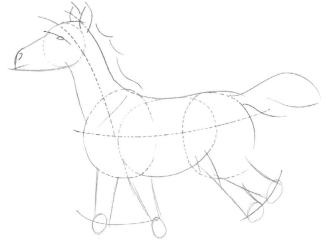

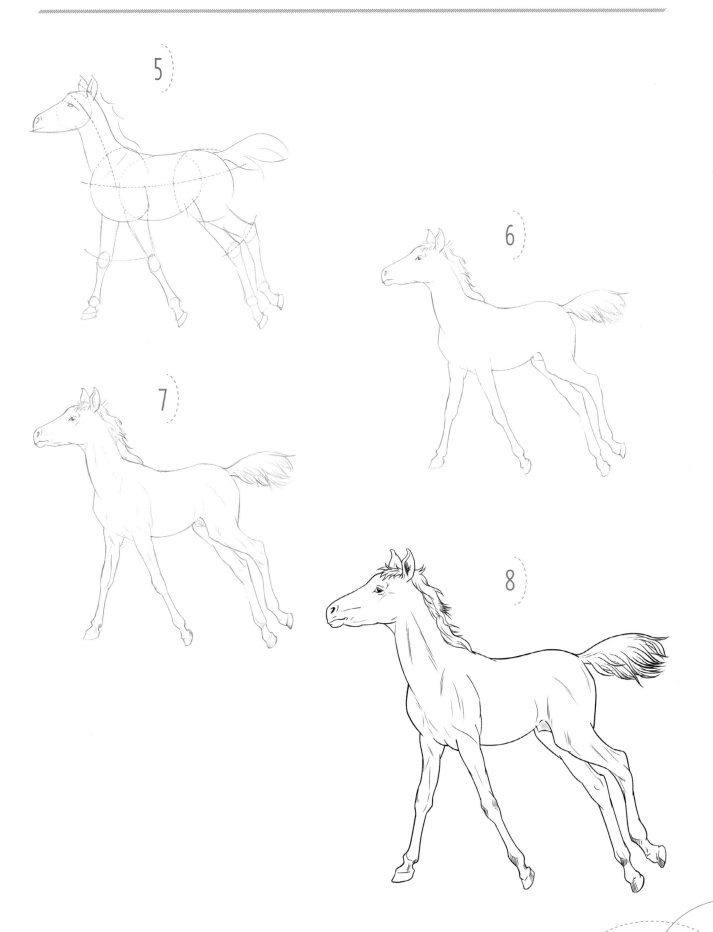

5

6

7

8

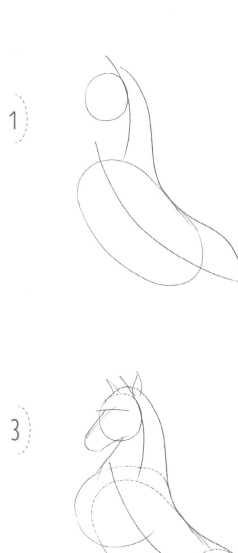

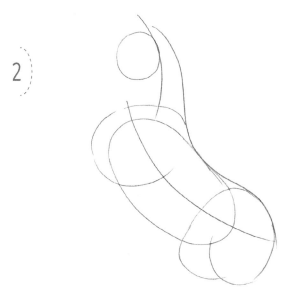

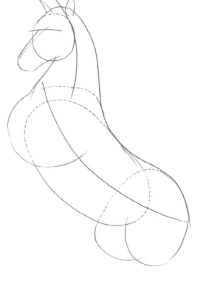

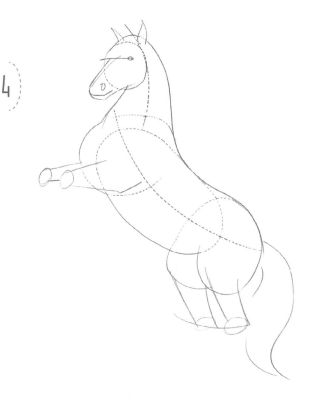

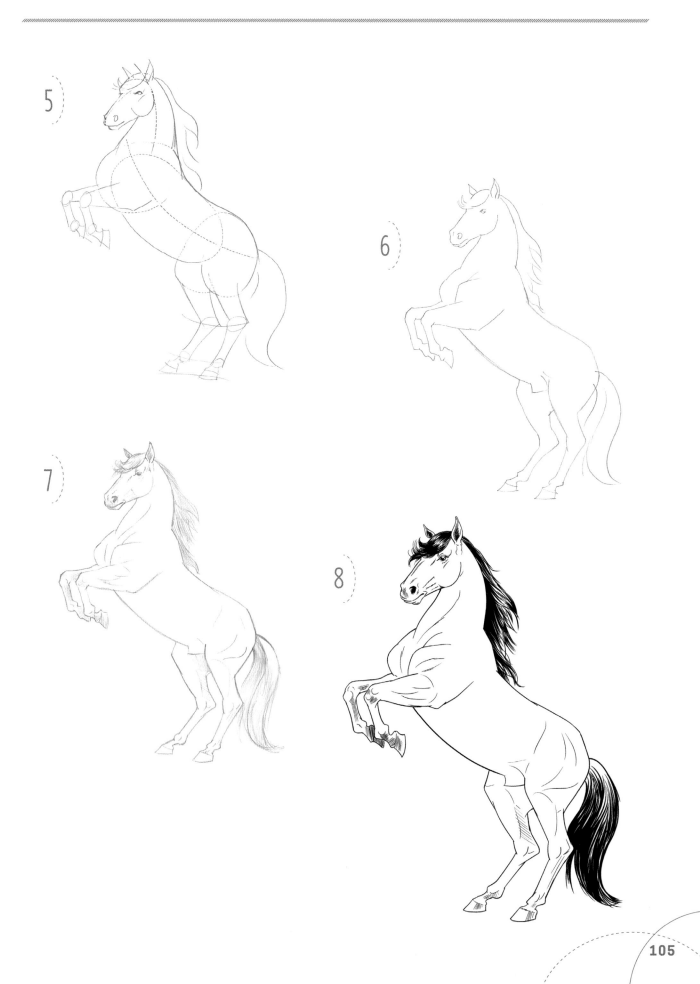

5

6

7

8

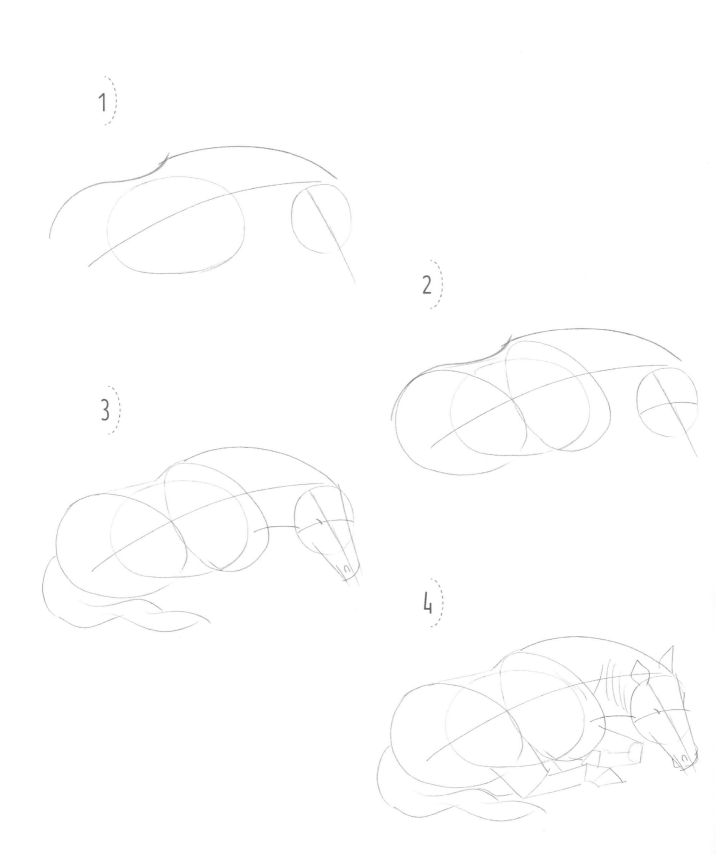

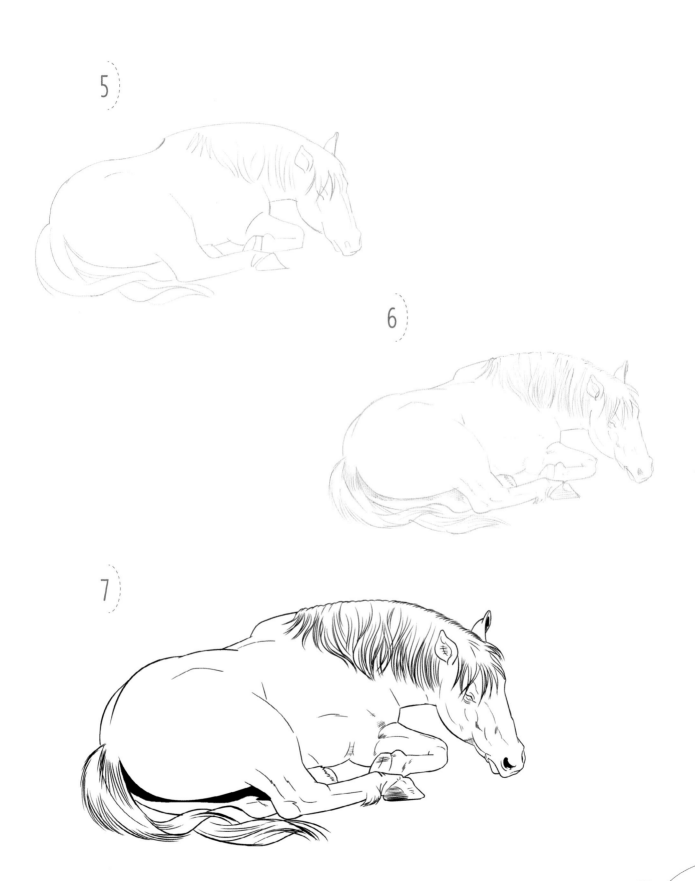

5

6

7

1

2

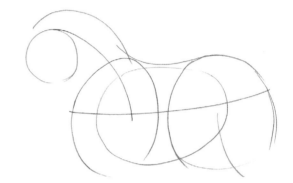

3

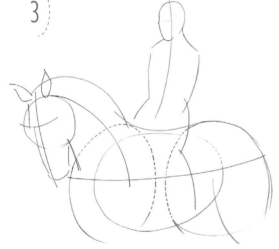

4

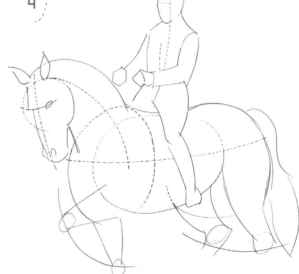

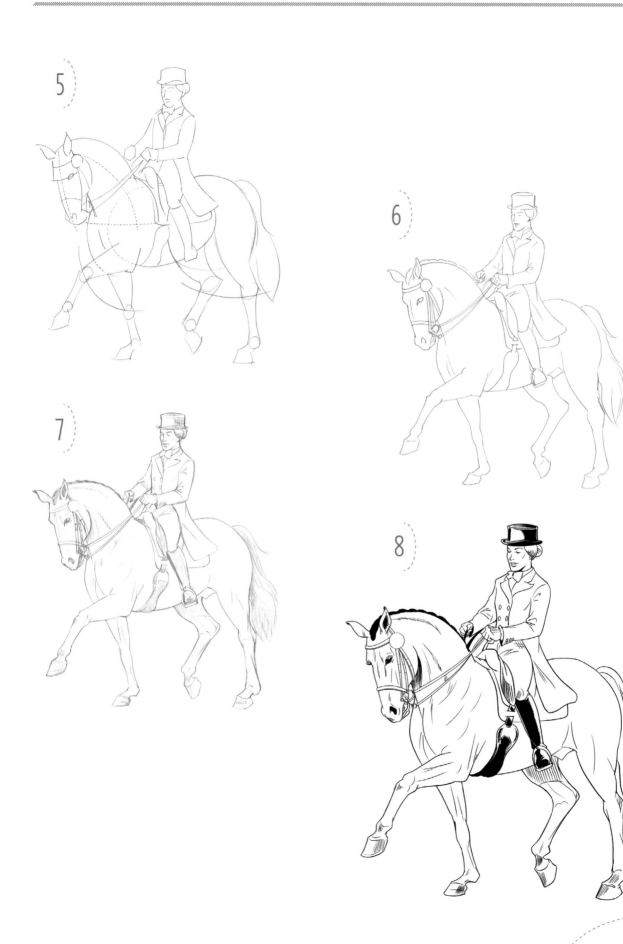

5

6

7

8

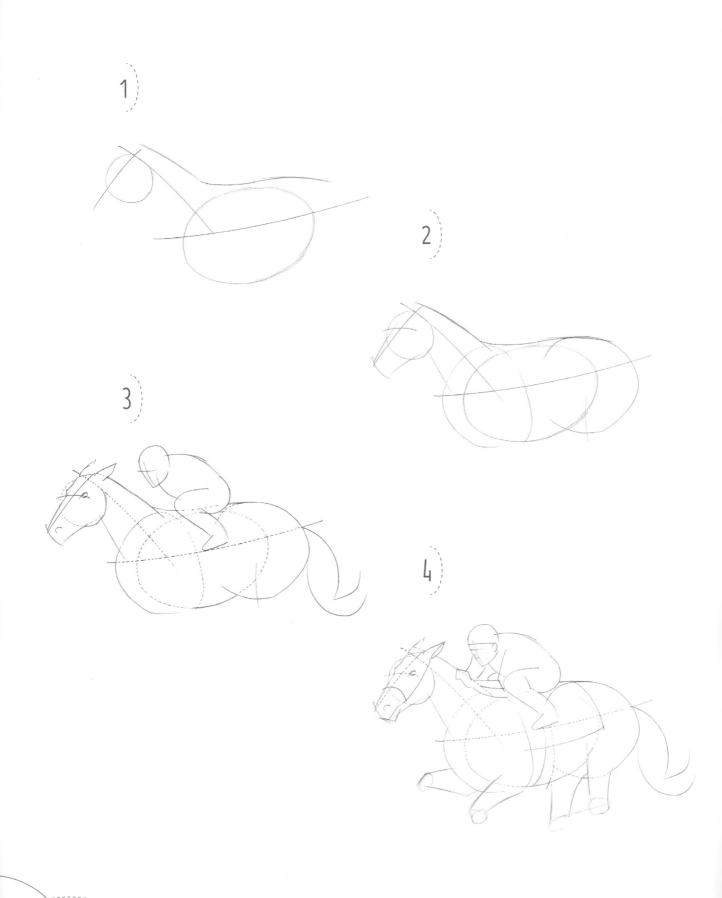

1

2

3

4

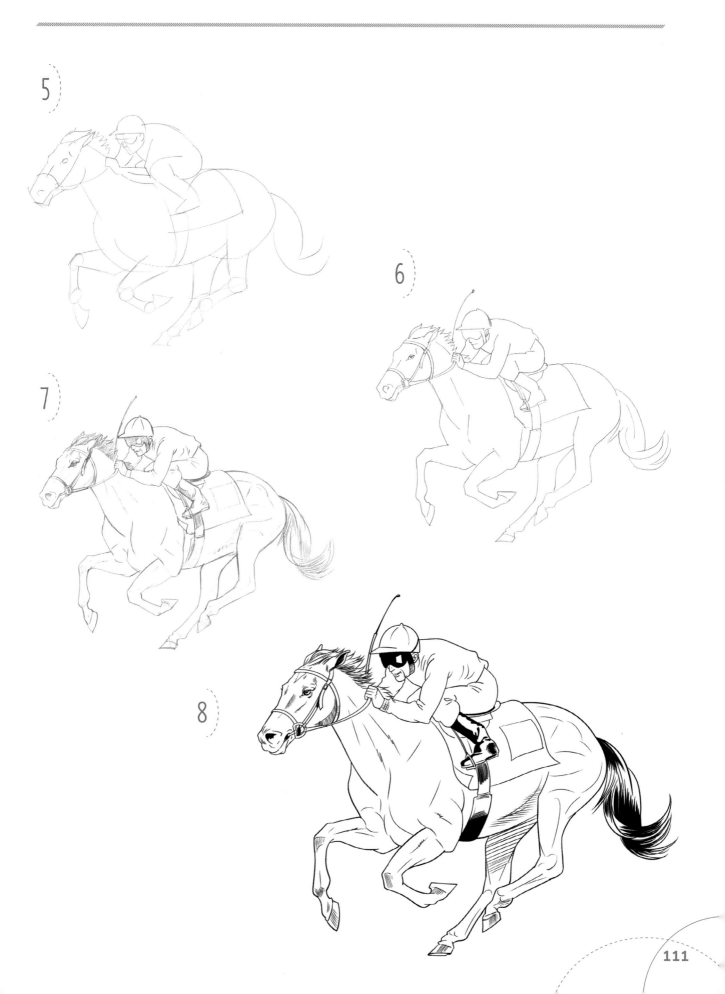

1

2

3

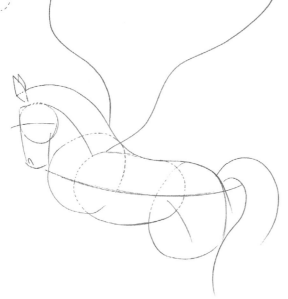

4

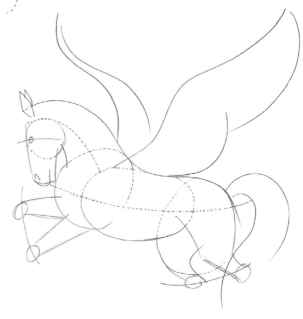

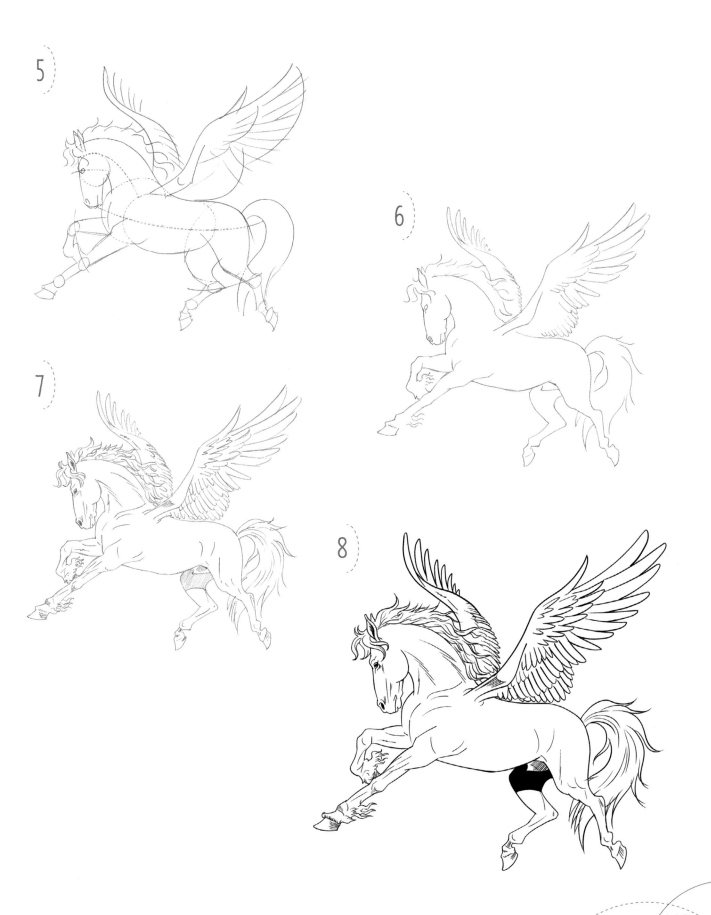

# UNICORN

1

2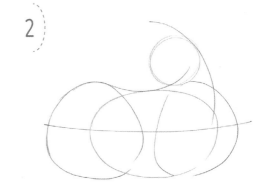

3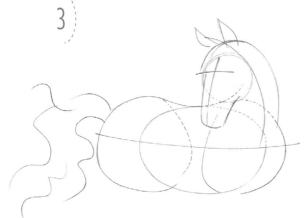

4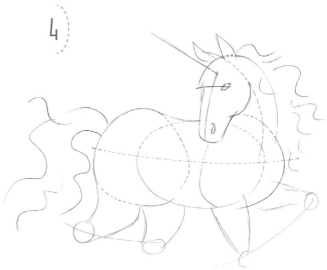

5

6

7

8

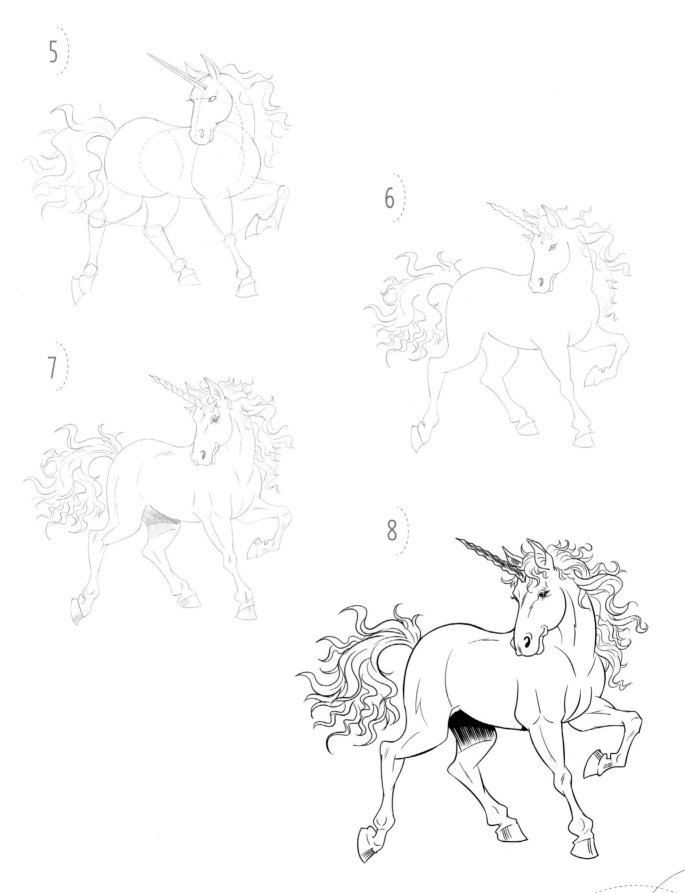

# MARINE ANIMALS

## DOLPHIN

1 Begin with a round shape for the body and a guideline to give a sense of movement.

2 Draw the tail and the head.

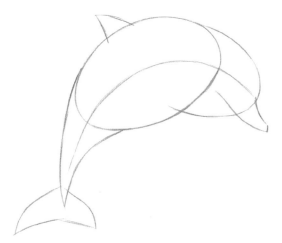

3 After placing the dorsal and tail fins, start on the beak.

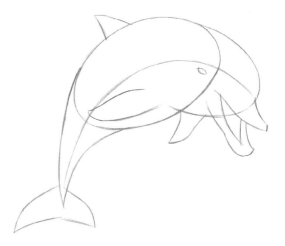

4 Continue with the beak and then sketch the pectoral fins. Don't forget the eye!

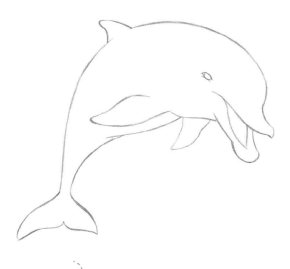

5 Erase the structural lines.

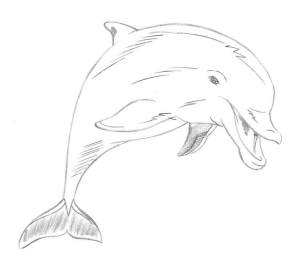

6 Add some details to make your drawing seem livelier.

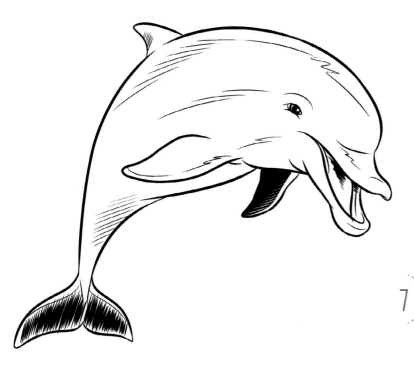

7 Go over the lines with a felt-tip pen or a brush with India ink.

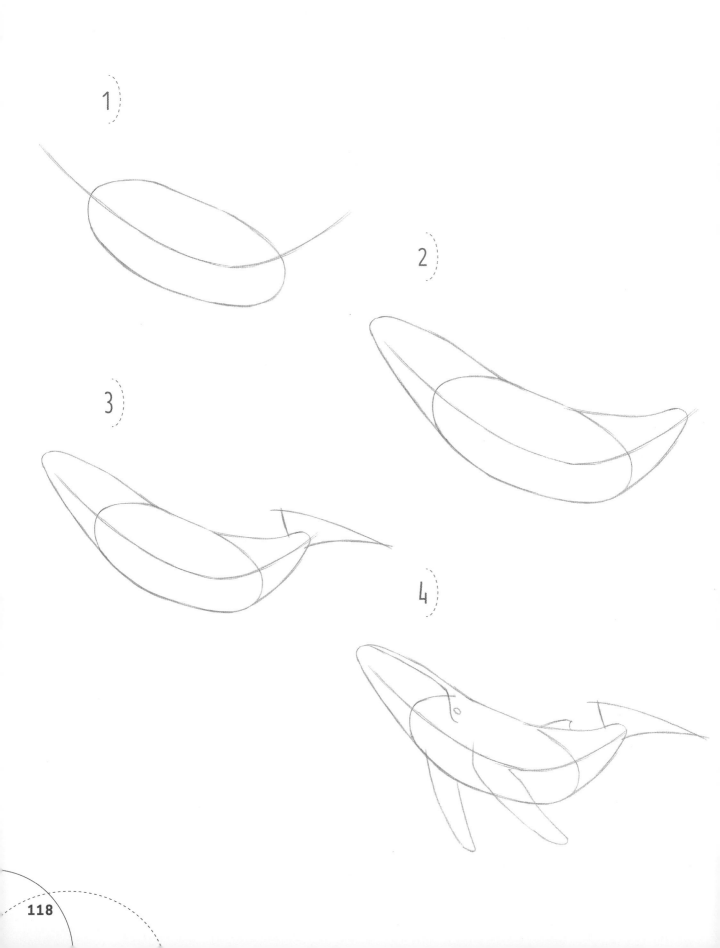

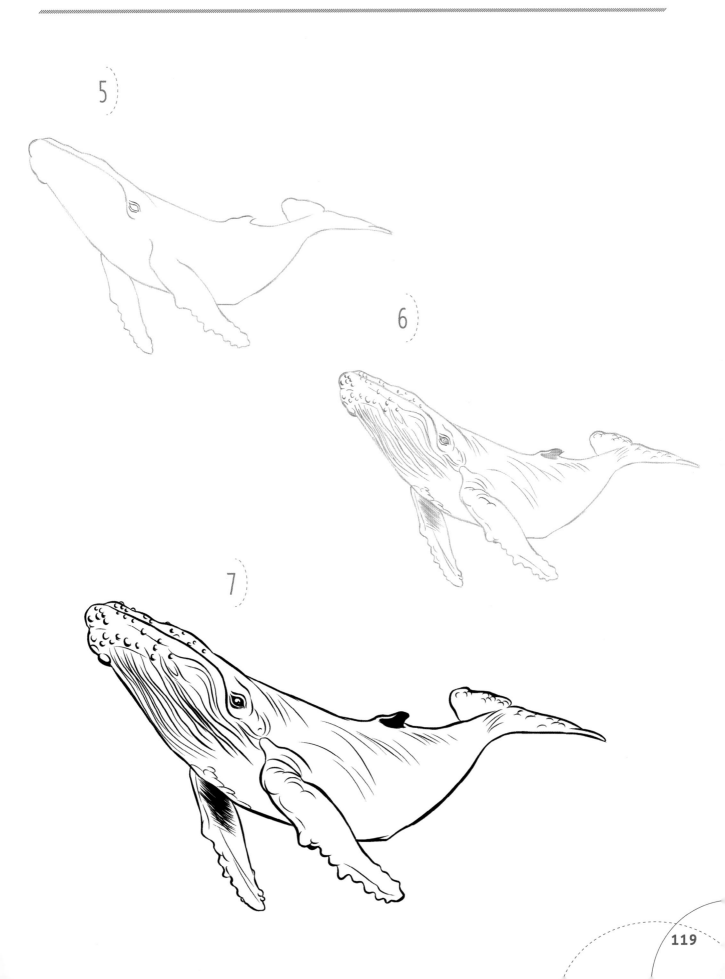

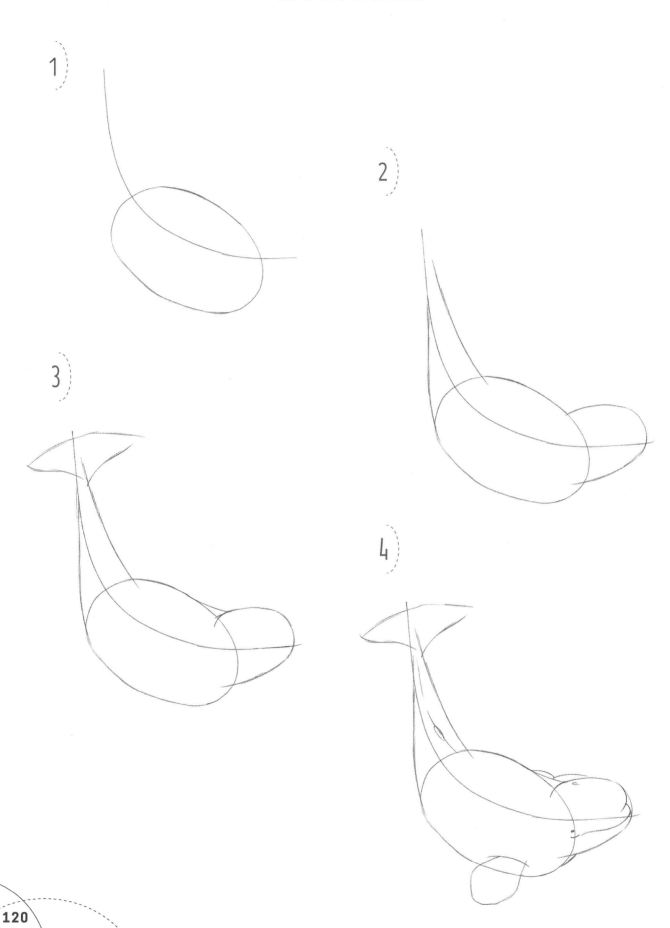

1

2

3

4

5

6

7

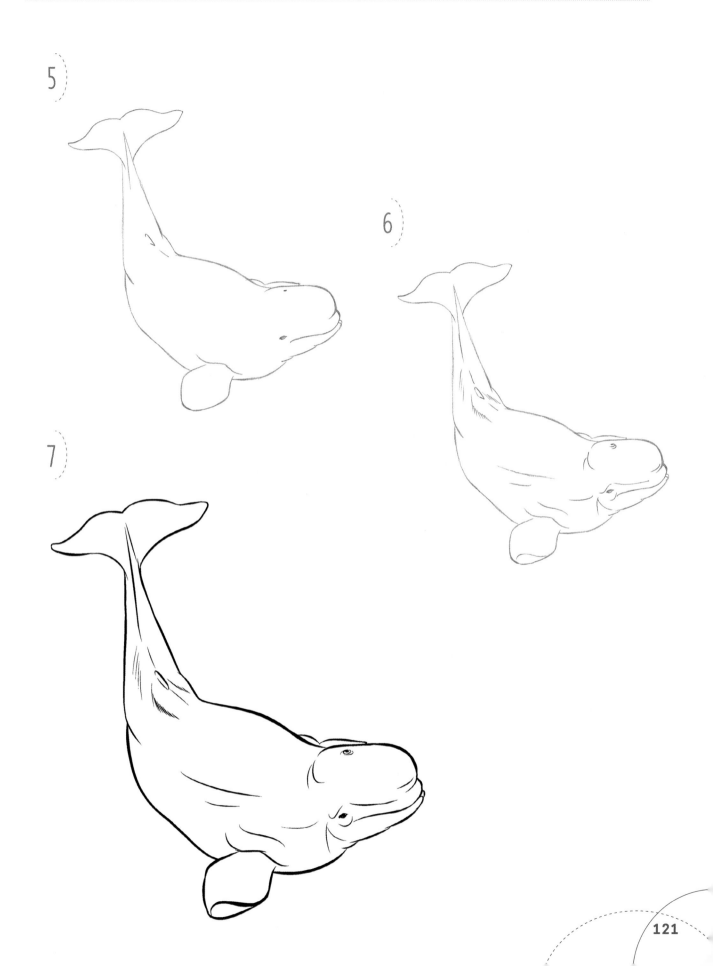

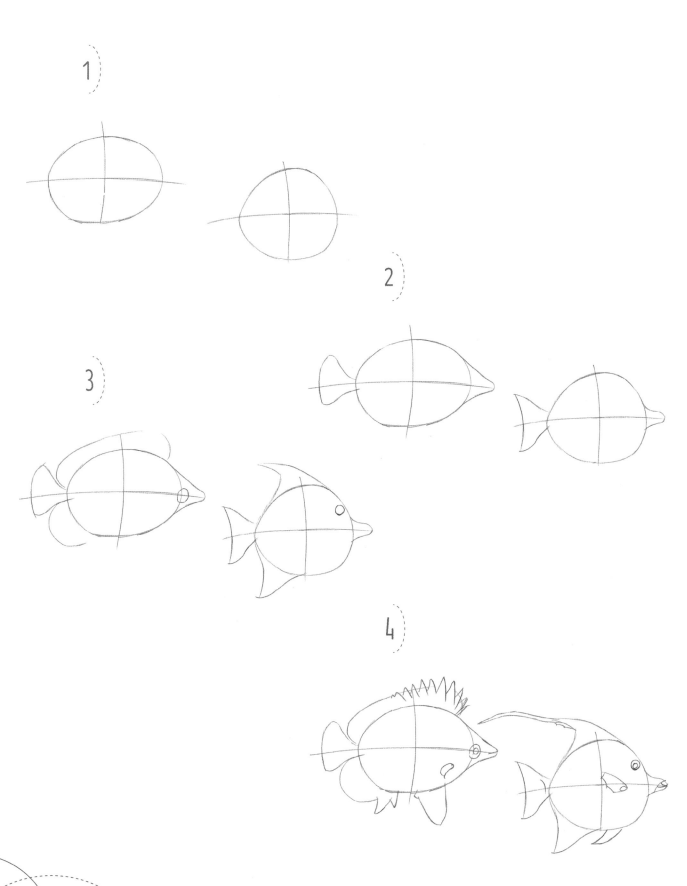

1

2

3

4

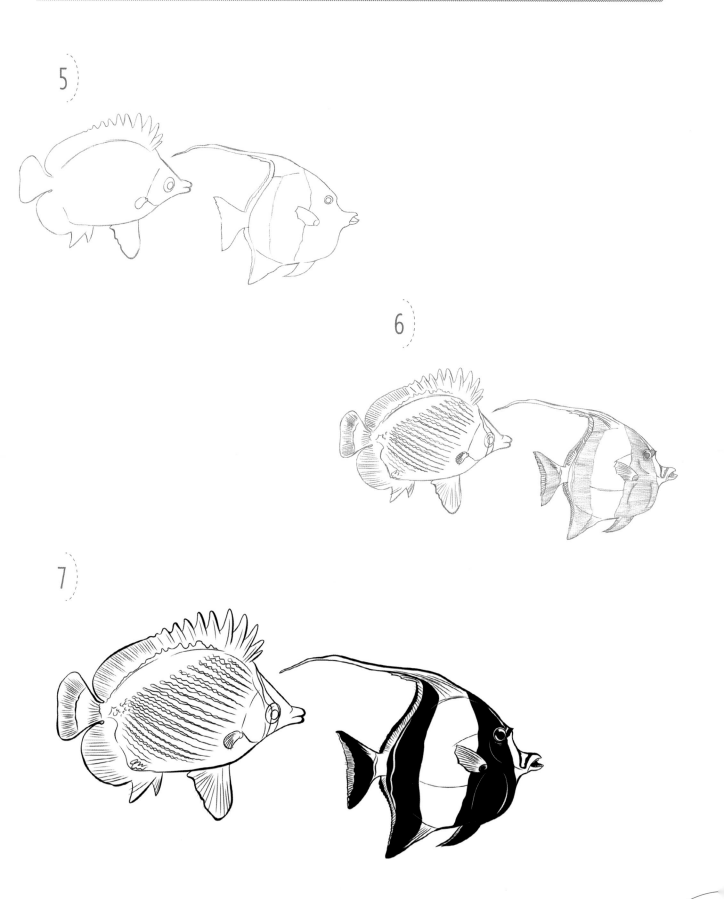

# SEAHORSE

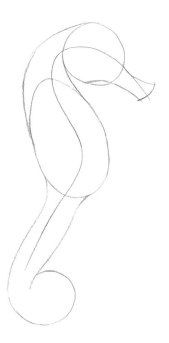

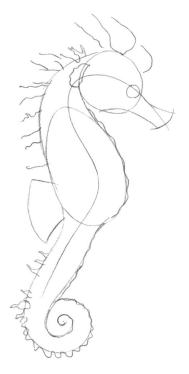

5

6

7

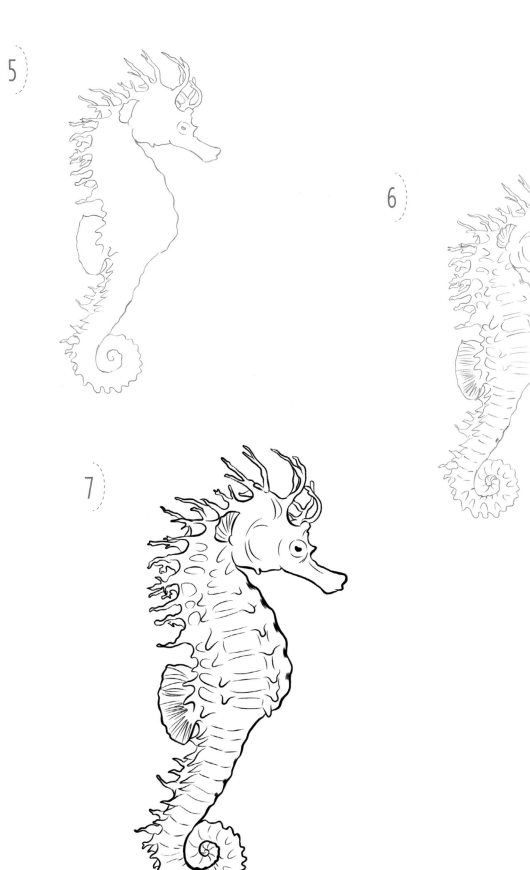

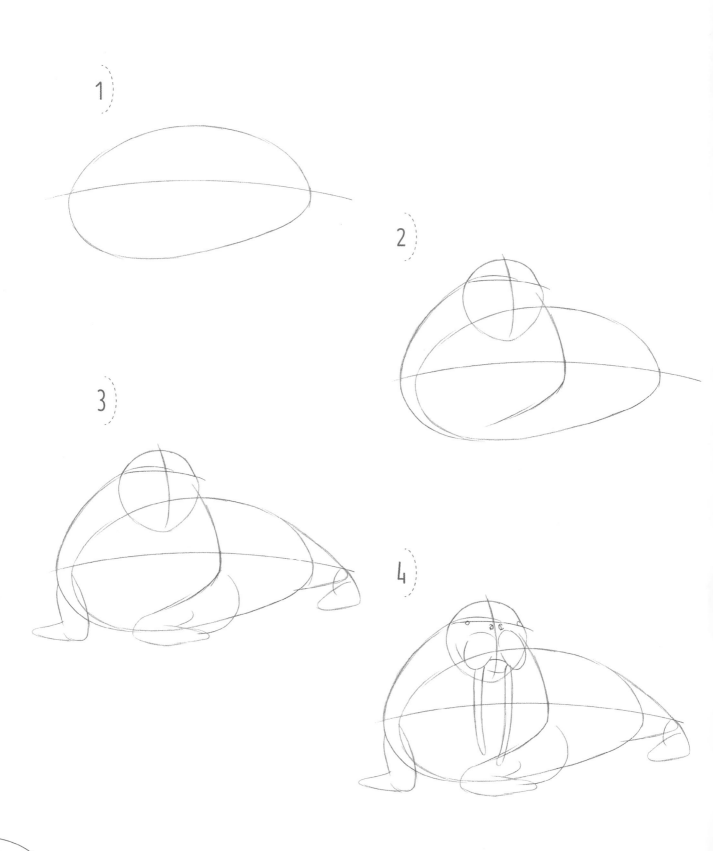

1

2

3

4

6

7

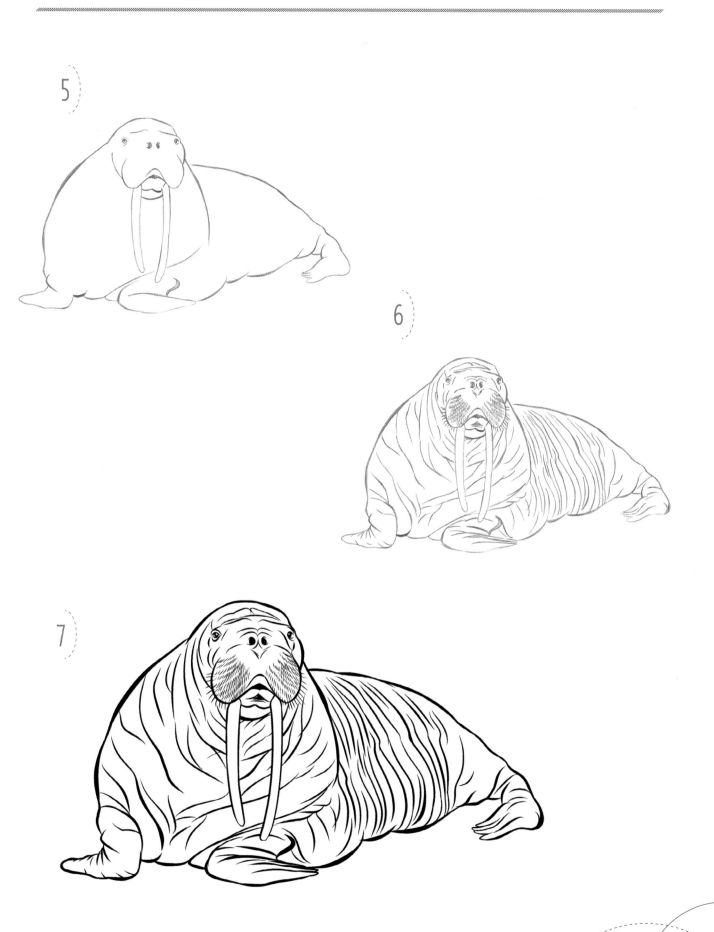

# NARWHAL

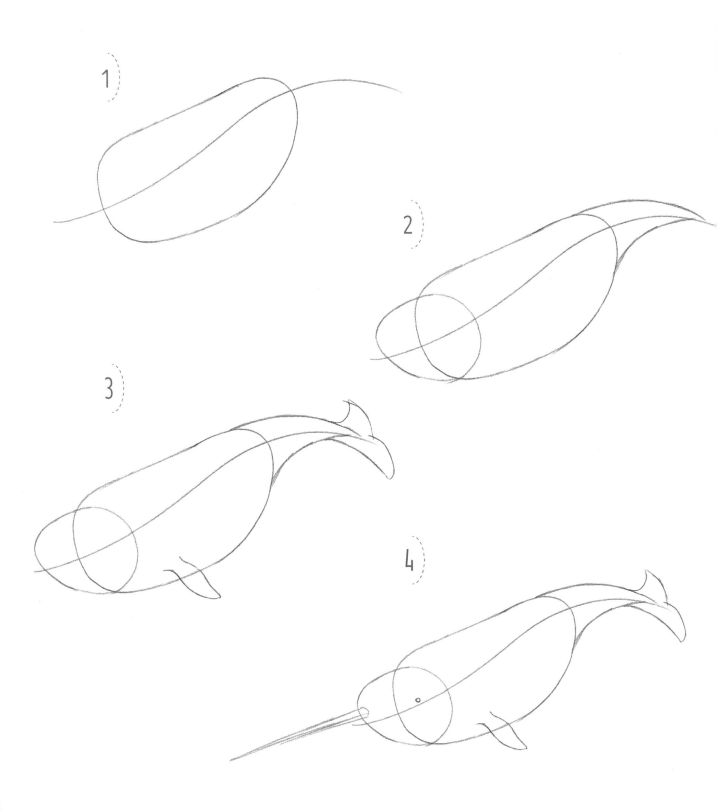

1

2

3

4

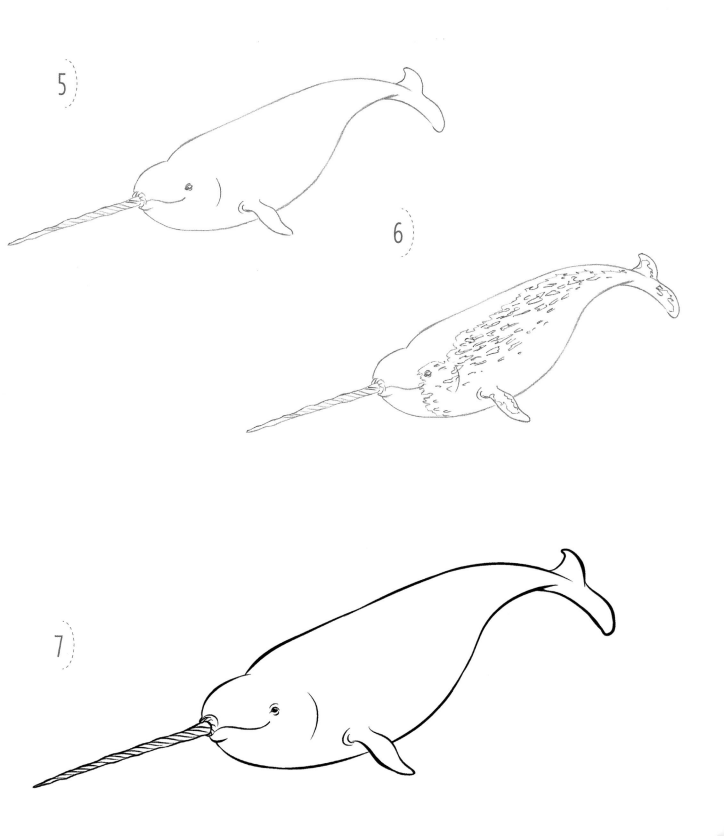

5

6

7

1

2

3
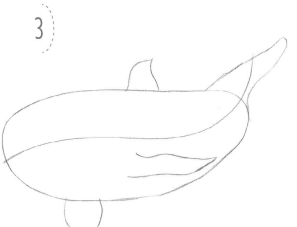

4

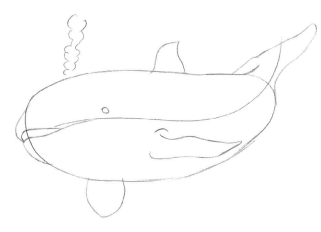

**5**

**6**

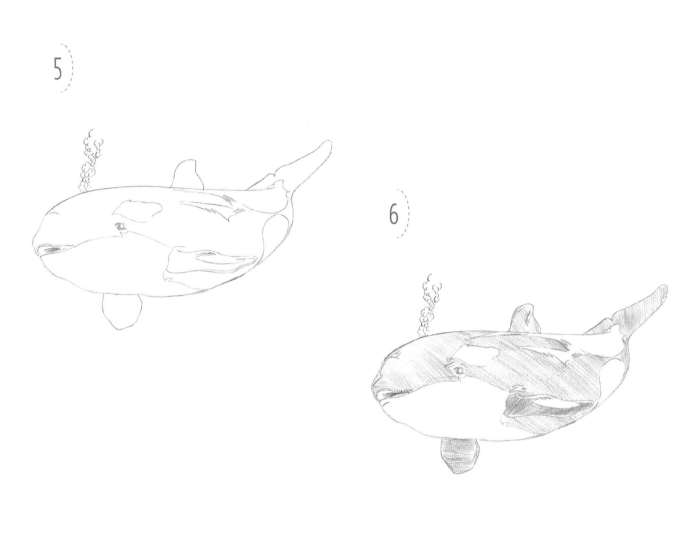

**7**

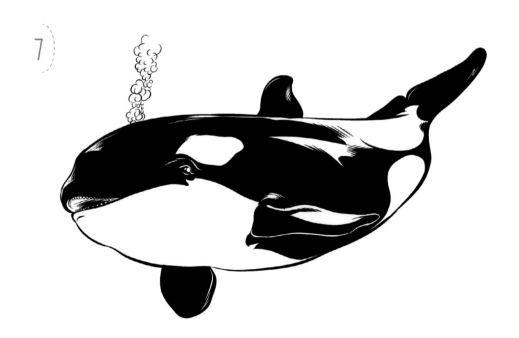

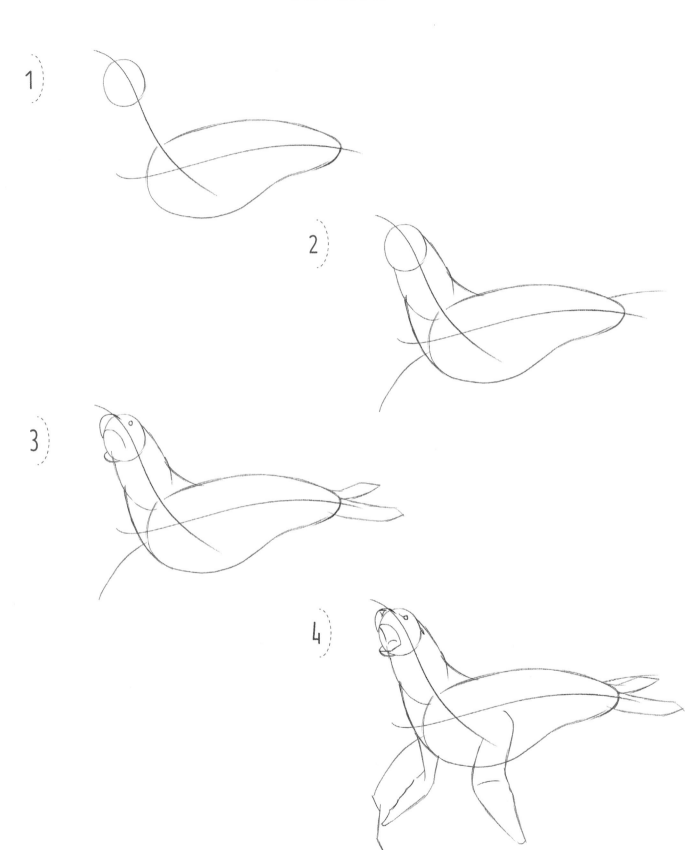

1

2

3

4

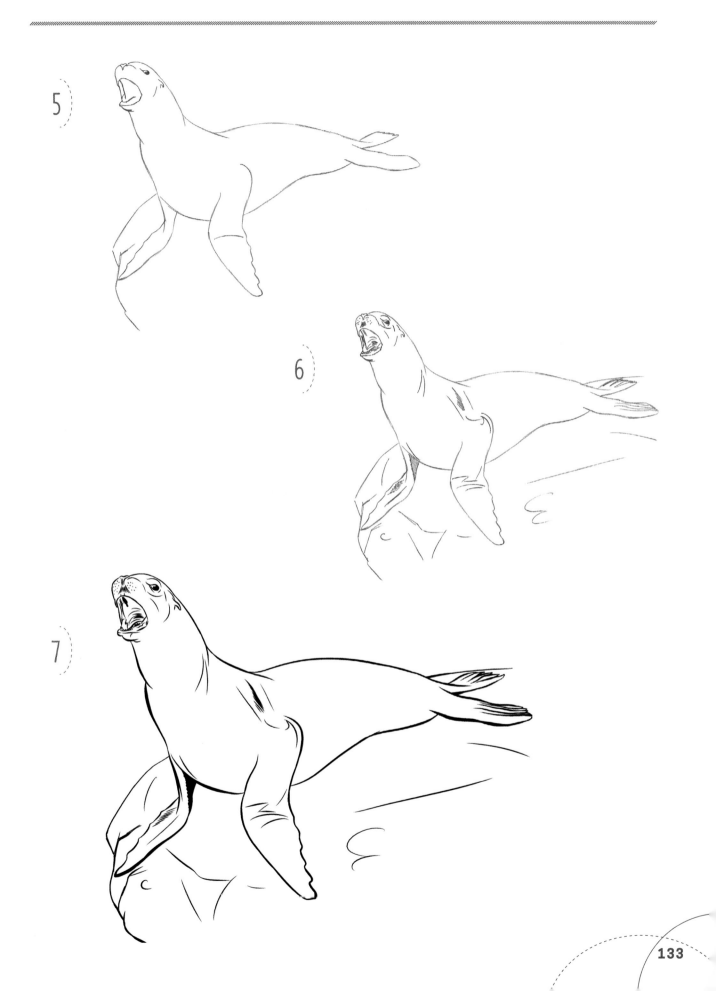

5

6

7

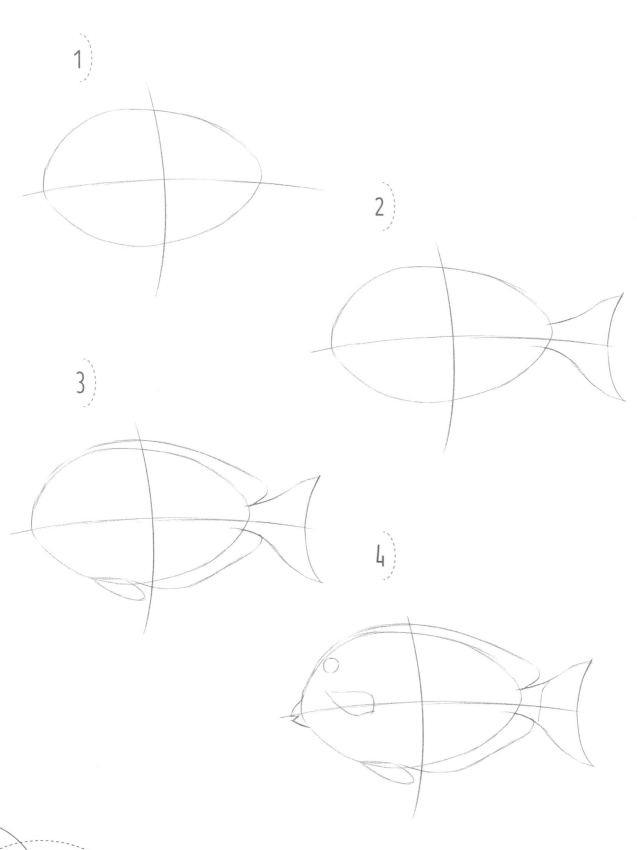

1

2

3

4

5

6

7

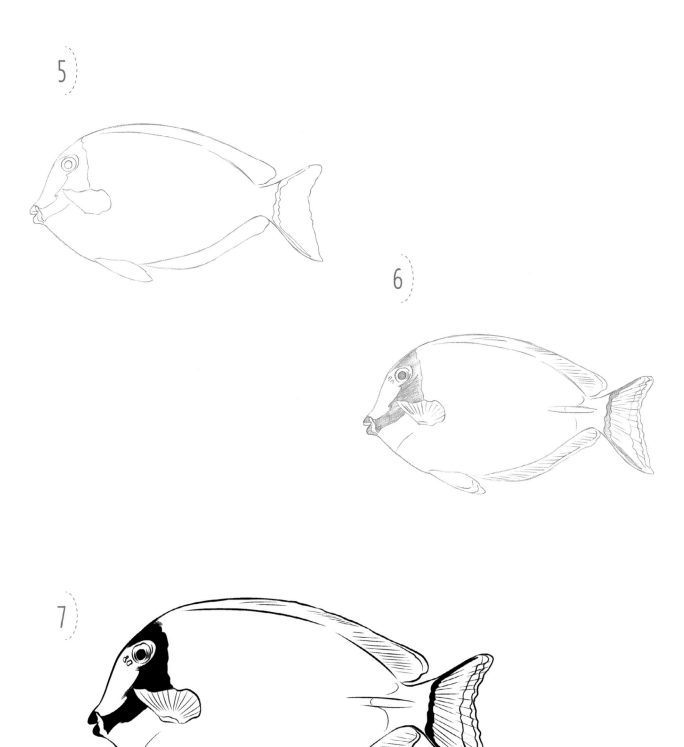

# CLOWN FISH

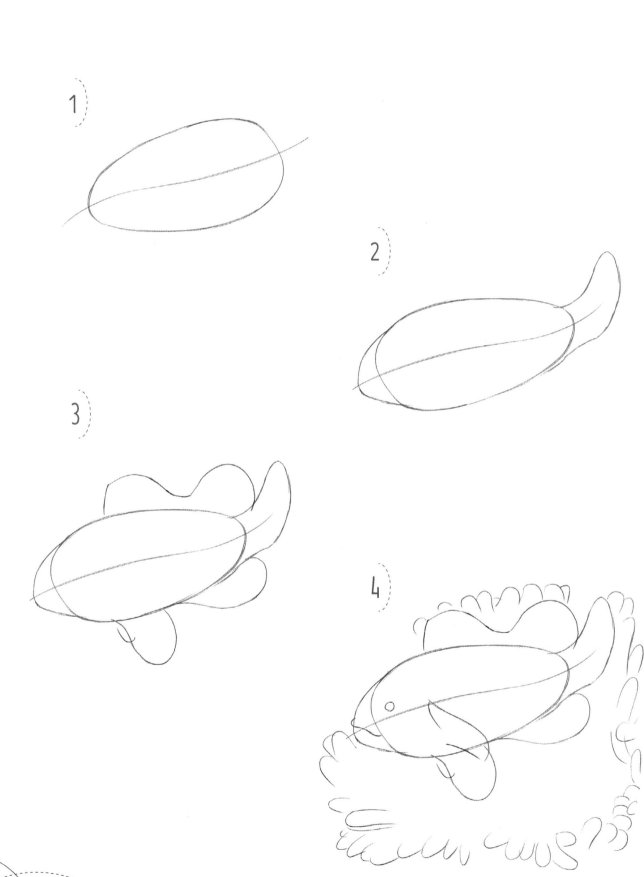

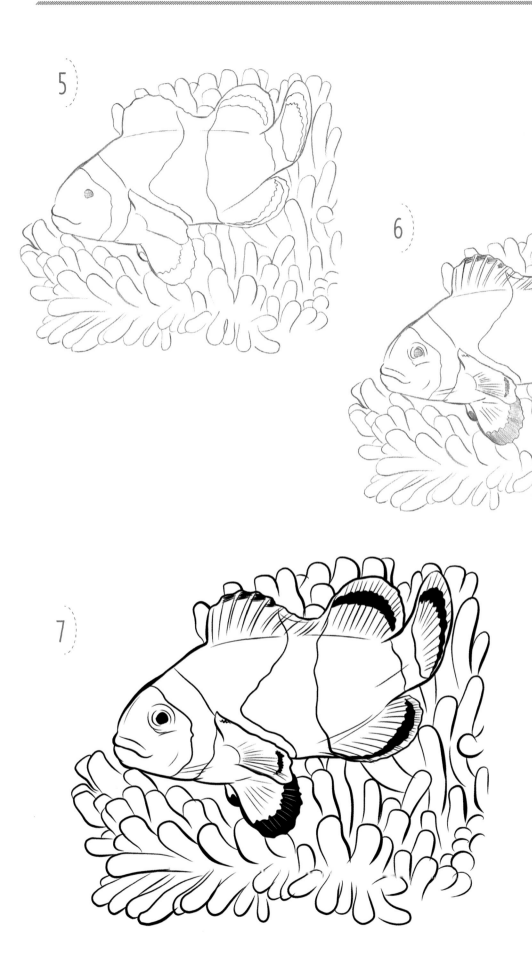

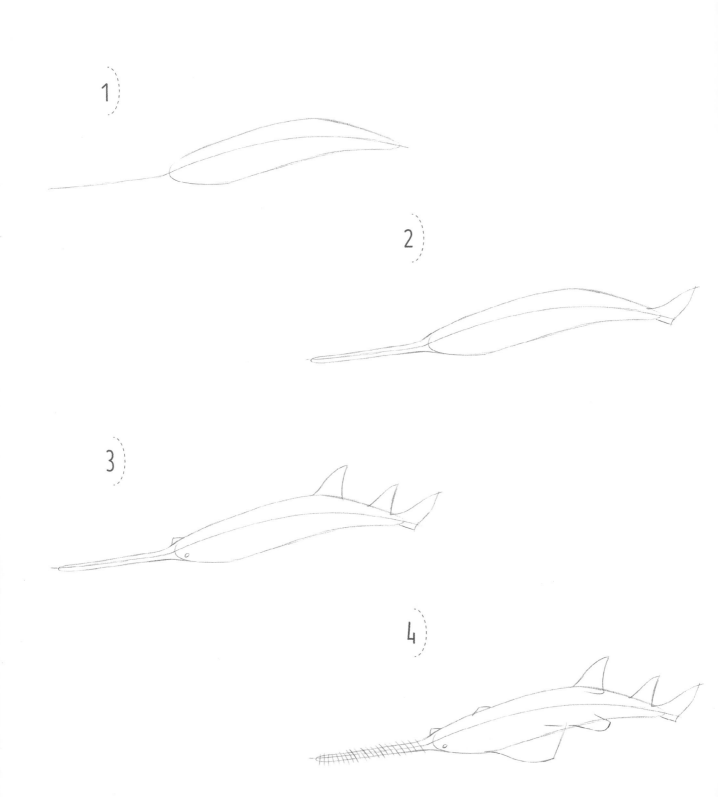

1

2

3

4

5

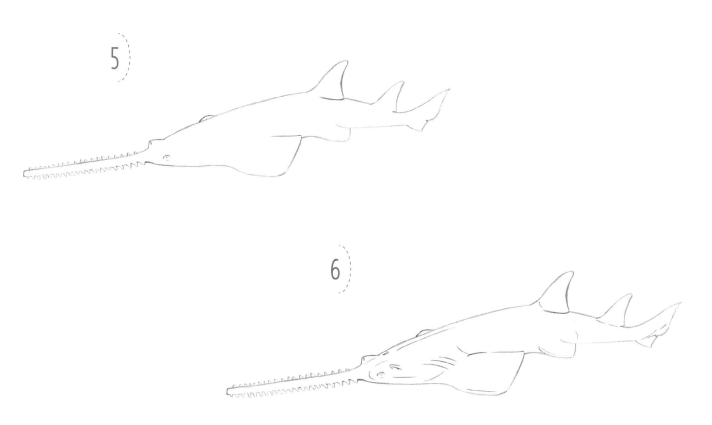

6

7

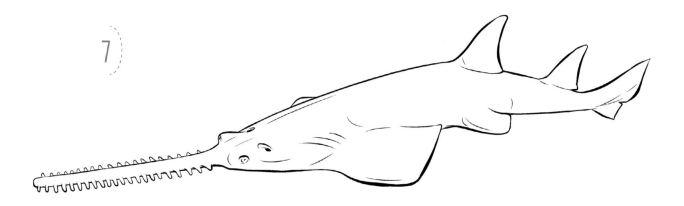

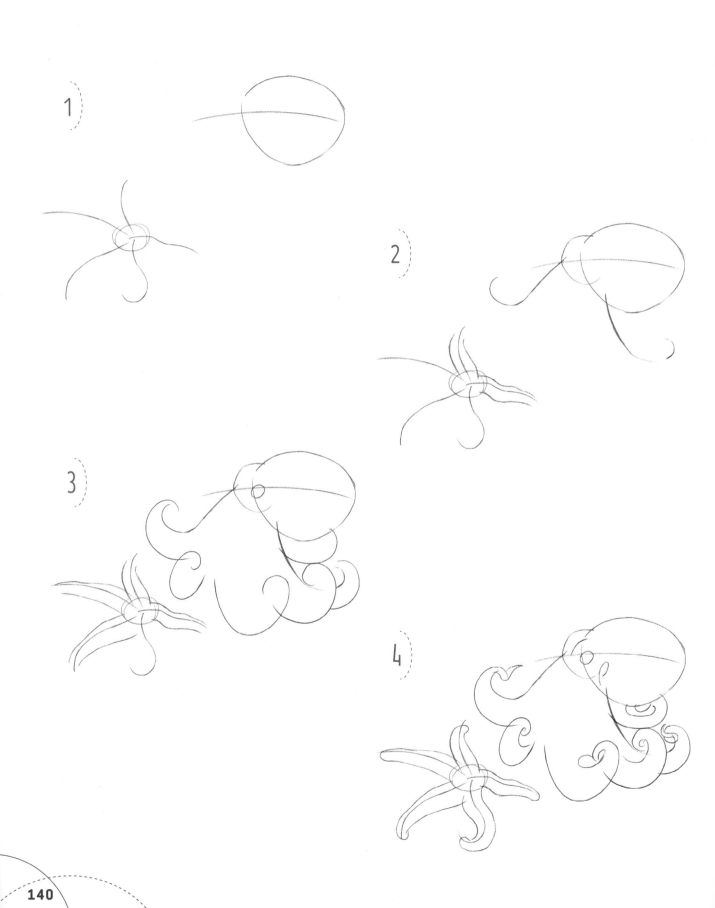

1

2

3

4

5

6

7

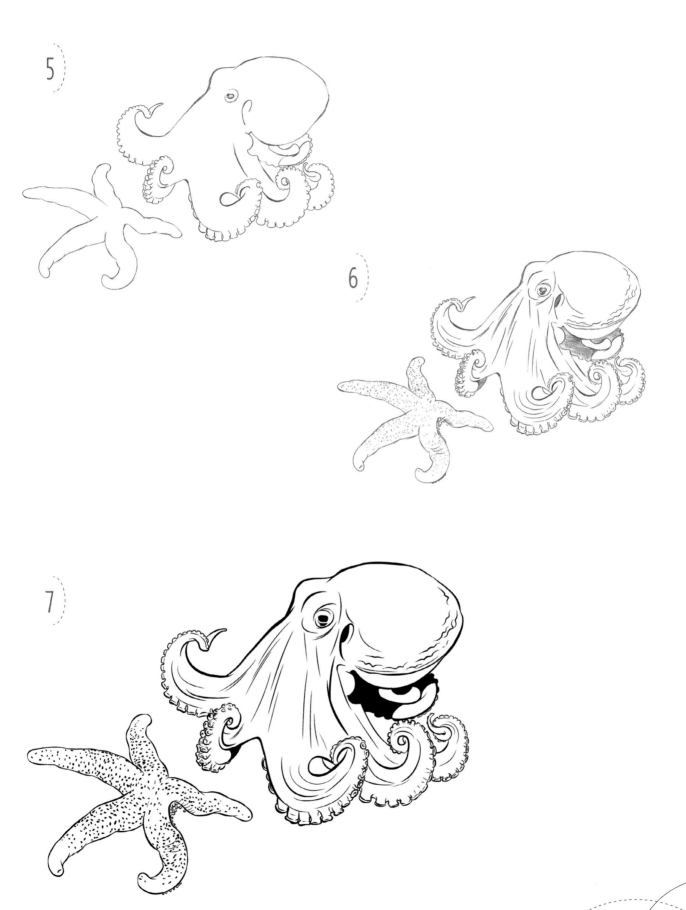

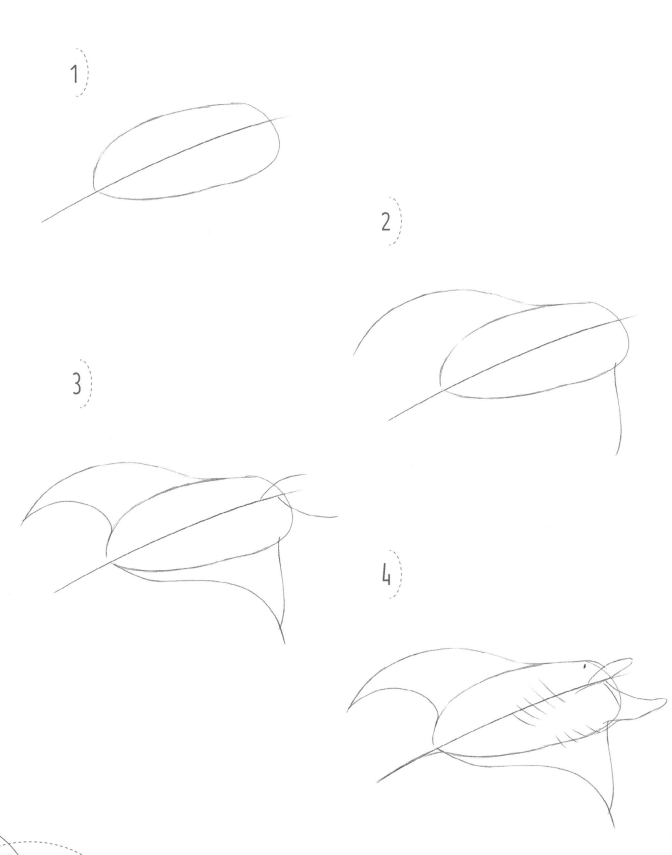

1

2

3

4

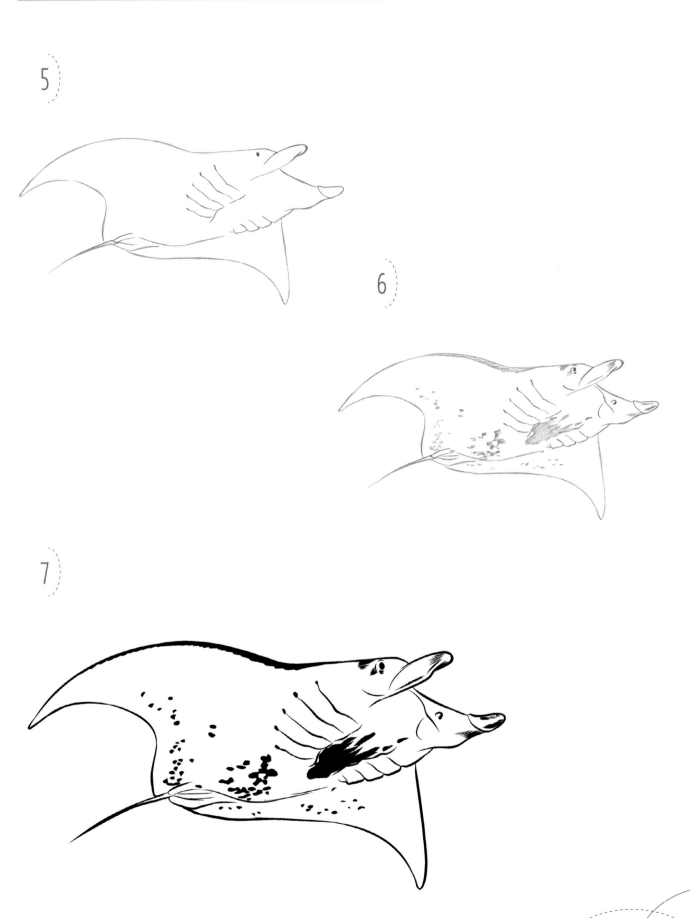

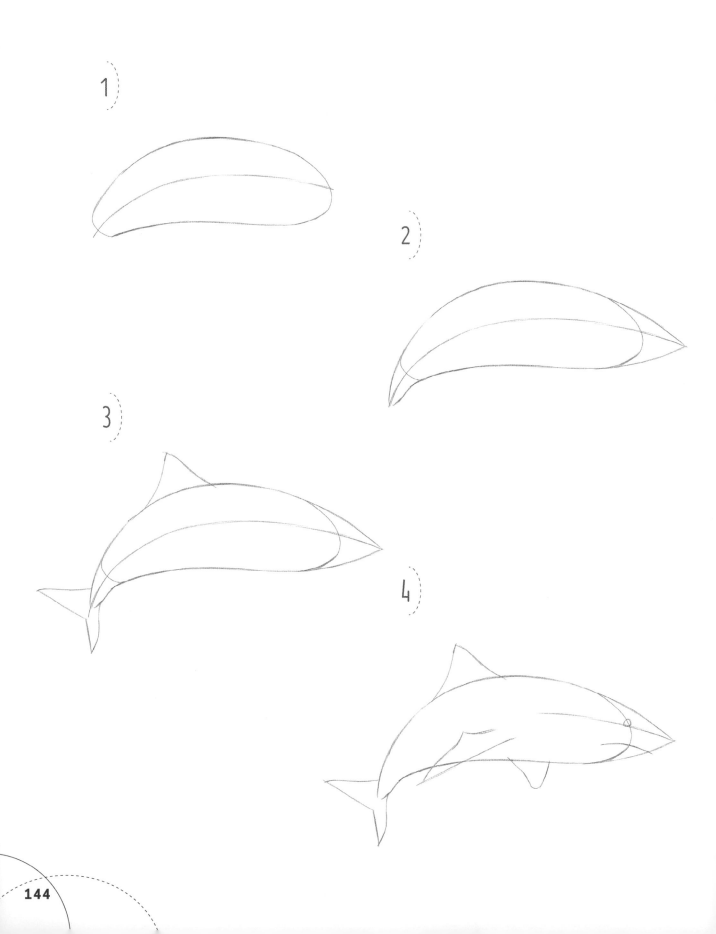

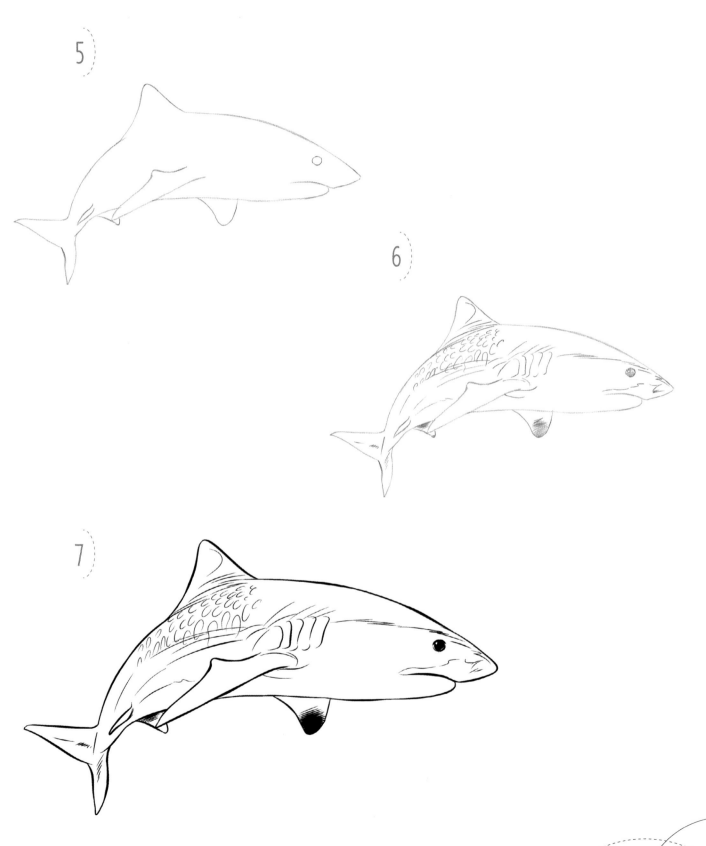

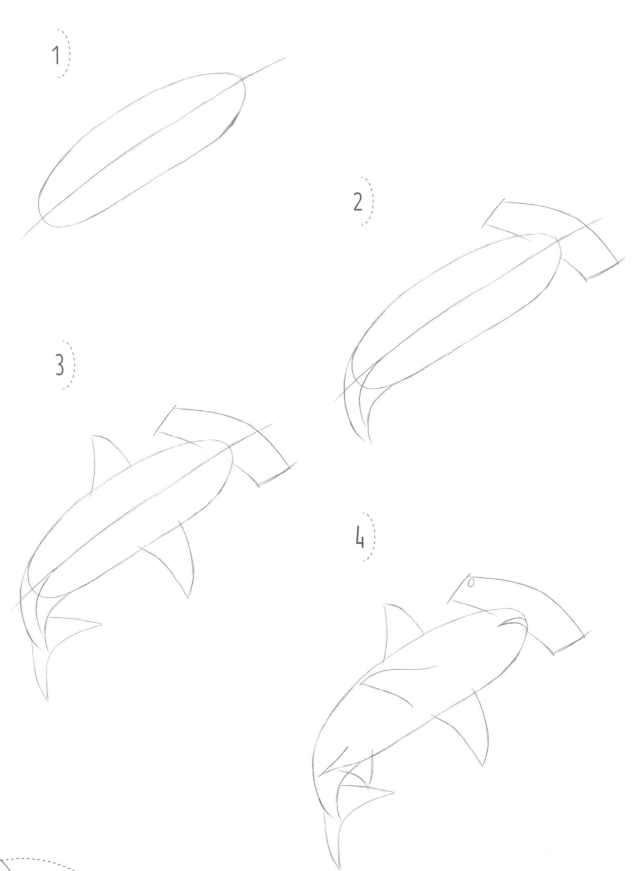

5

6

7

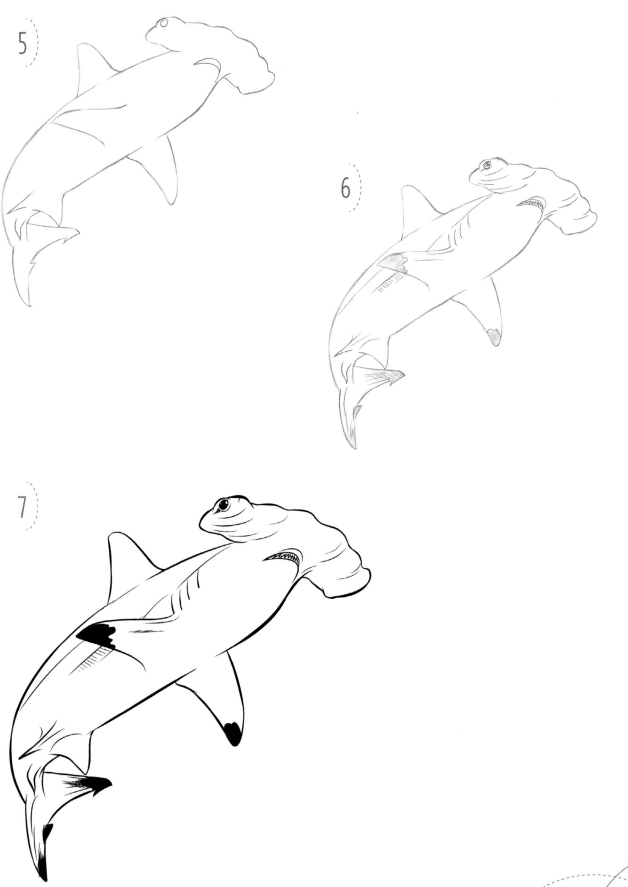

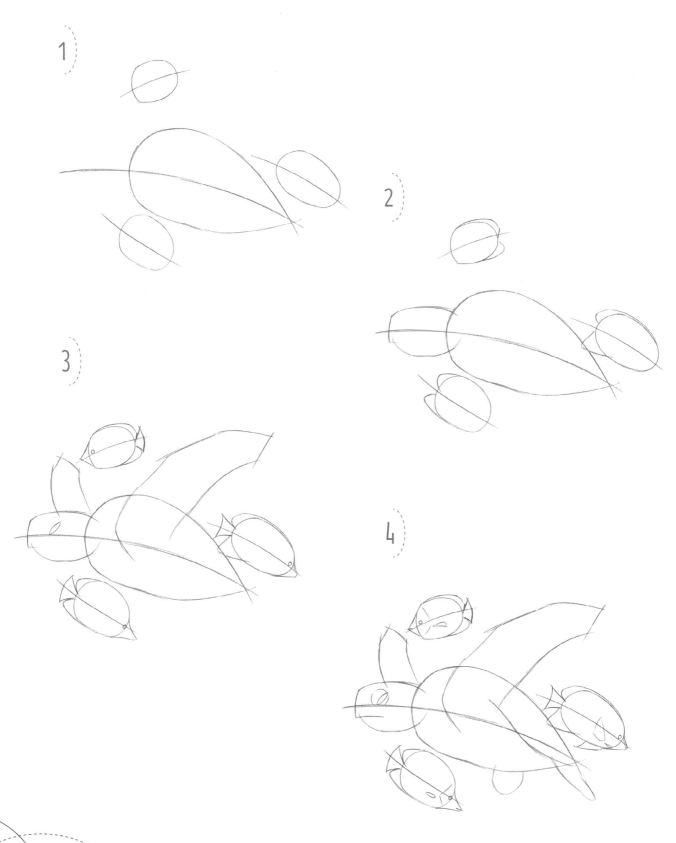

1

2

3

4

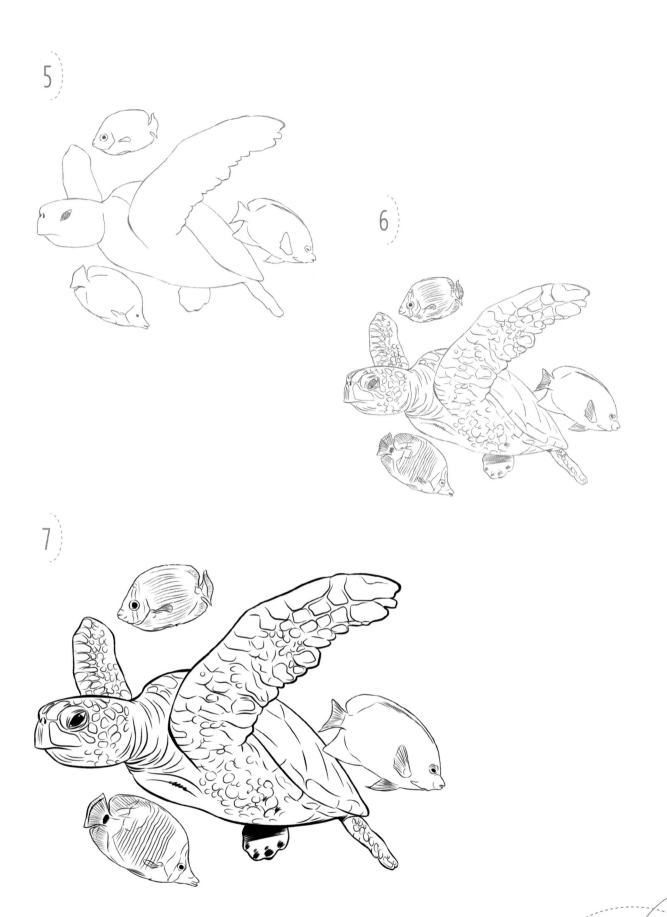

5

6

7

# WILD ANIMALS

## LION

1) Draw an oval for the head.

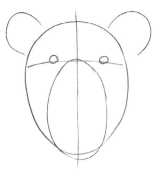

2) Sketch the general shape of the face.

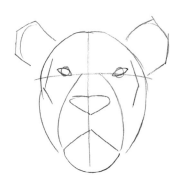

3) Sketch the eyes, ears, nose and mouth.

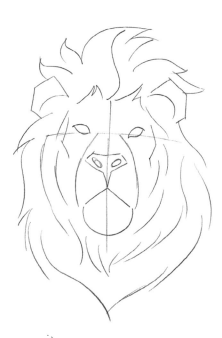

4) Outline the mane.

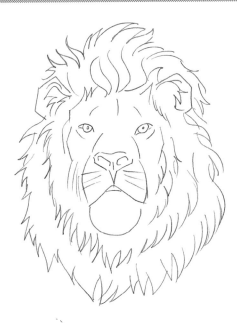

5 ) Erase the structural lines and refine the details.

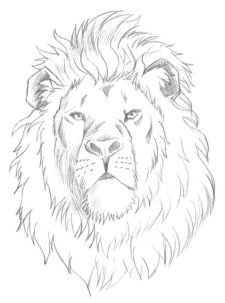

6 ) Finalize the pencil sketch.

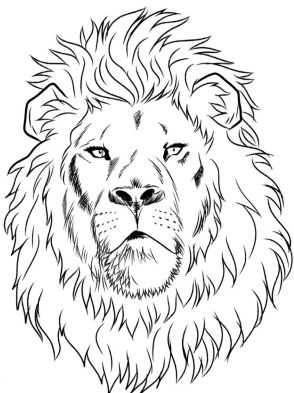

7 ) Ink the piece with a felt-tip pen or a brush with India ink.

1

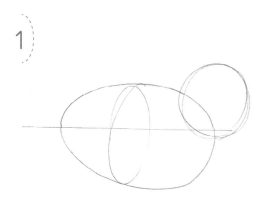

2

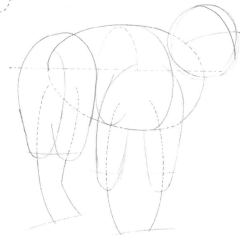

3

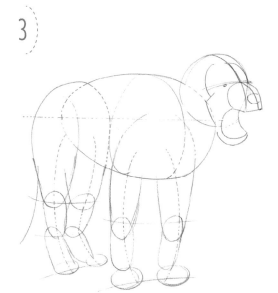

4

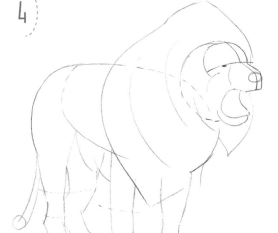

5

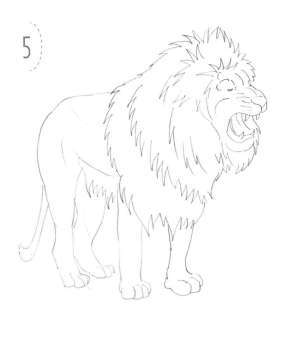

6

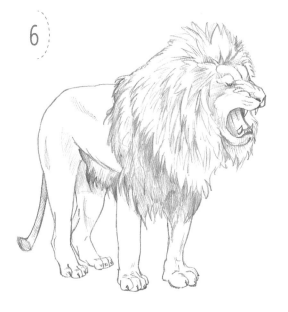

7

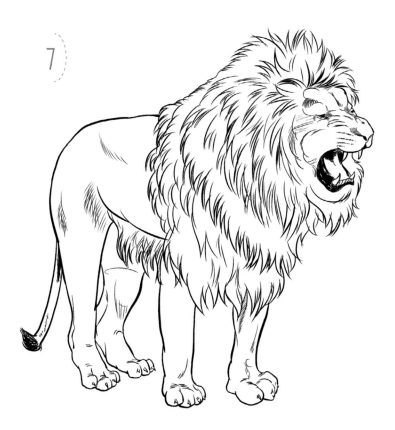

# TIGER

1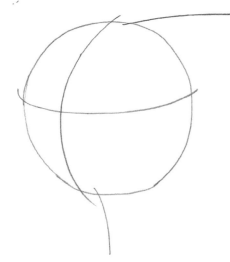

2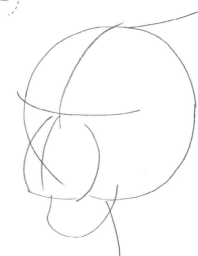

3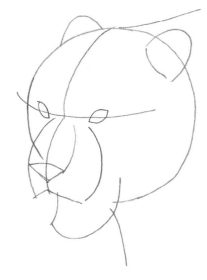

4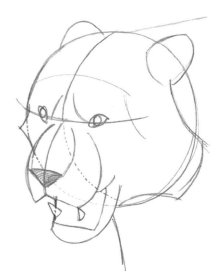

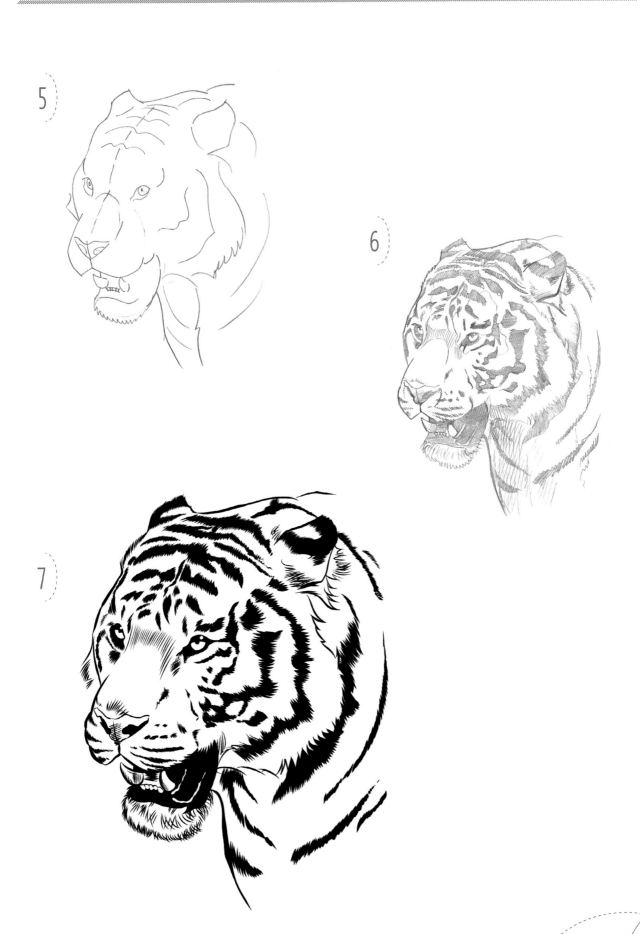

1

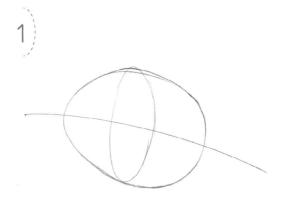

2

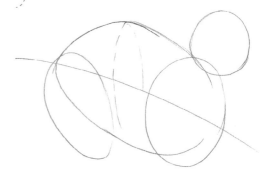

3

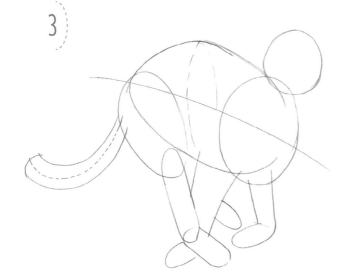

4

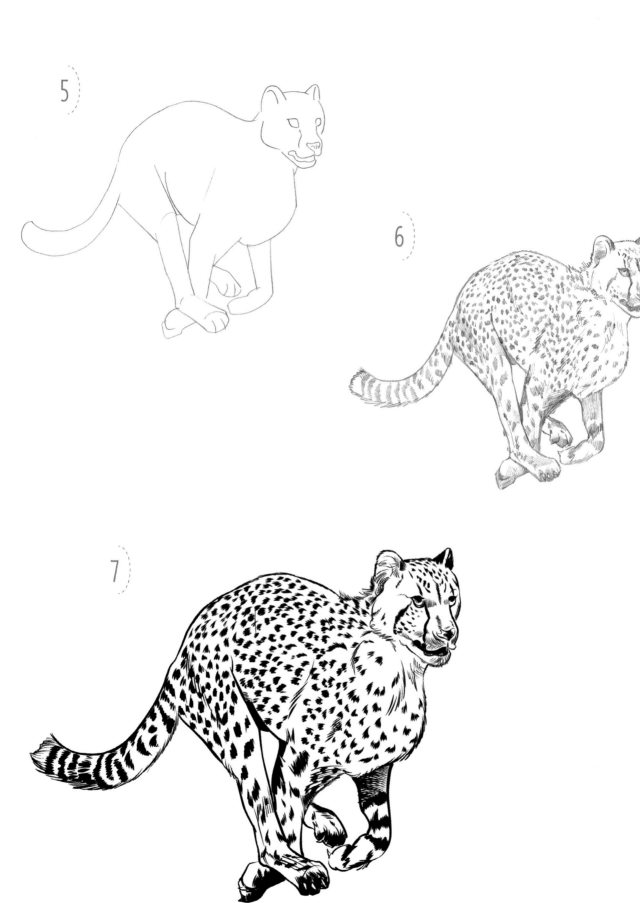

1

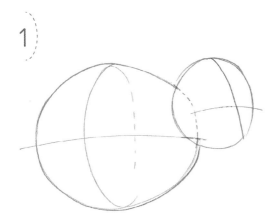

2

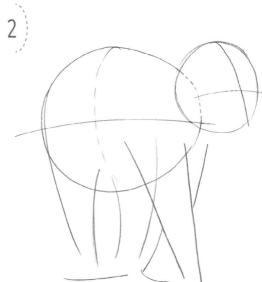

3

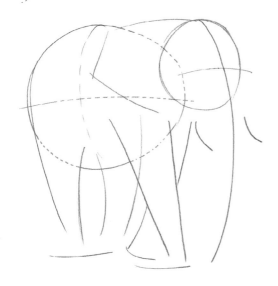

4

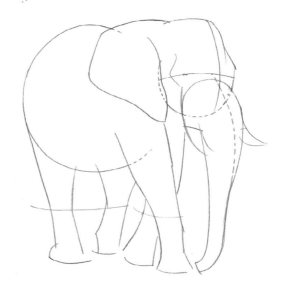

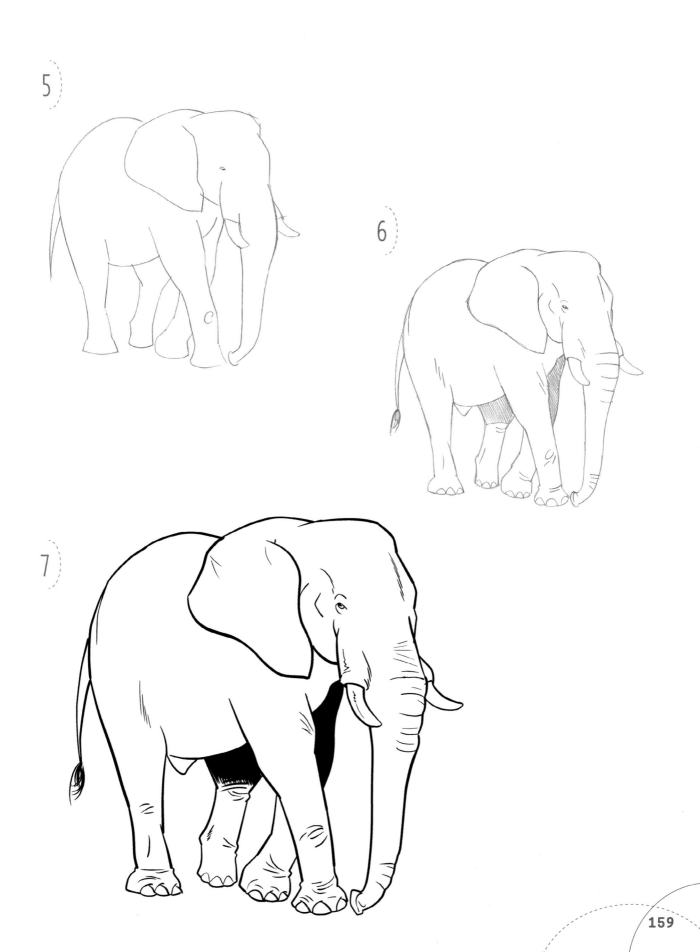

5

6

7

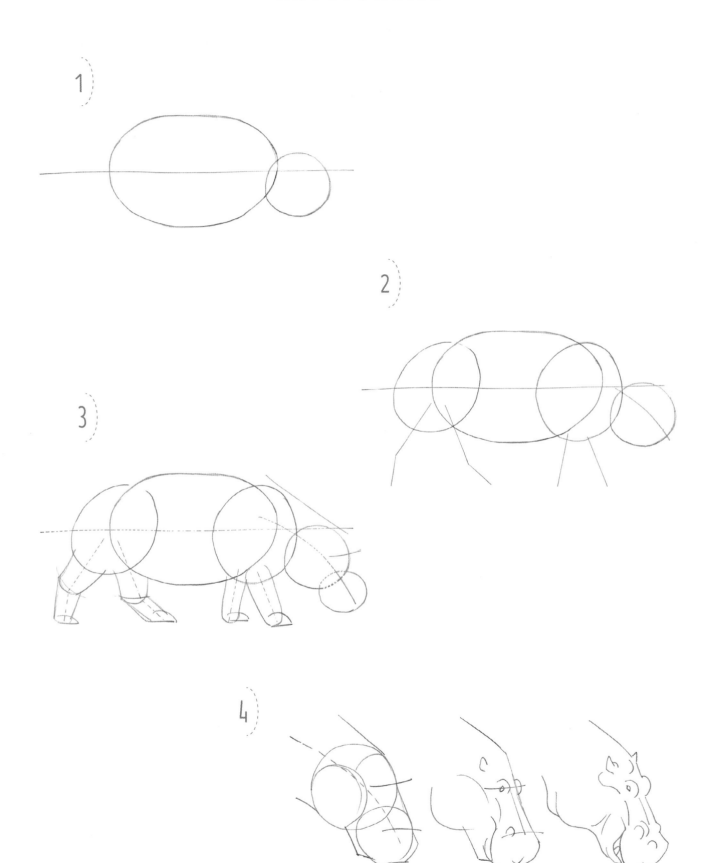

5

6

7

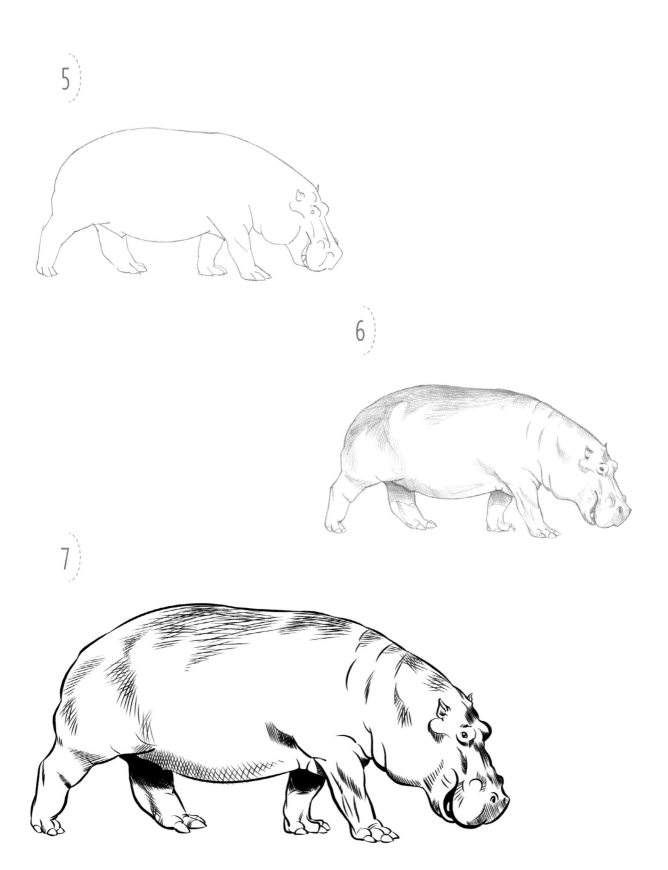

# RHINOCEROS

1

2

3

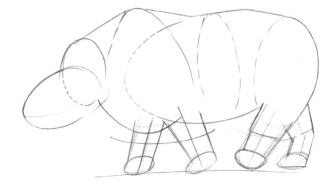

4

 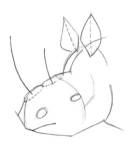 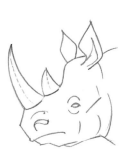

5

6

7

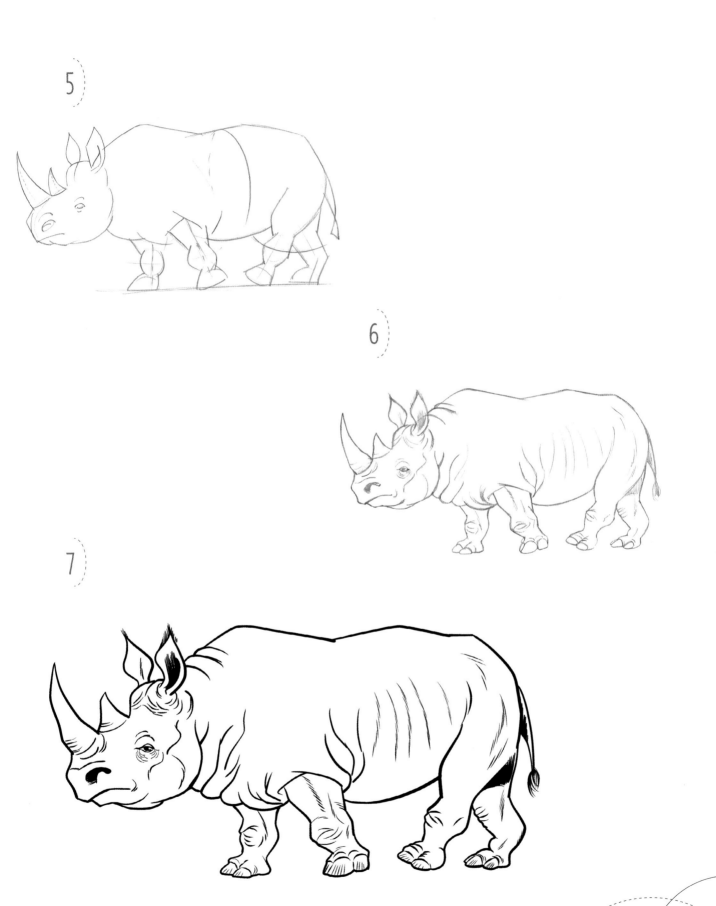

1

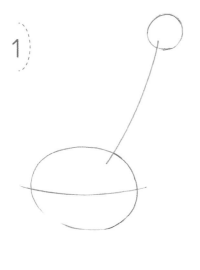

2

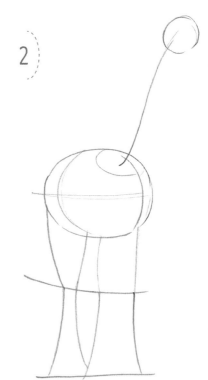

3

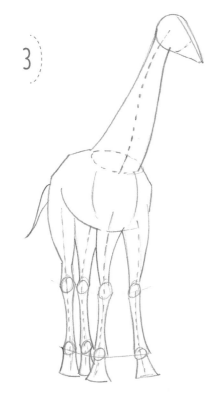

4

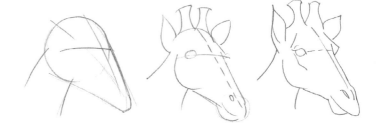

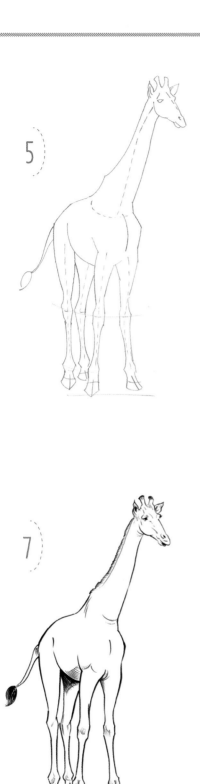

5

6

7

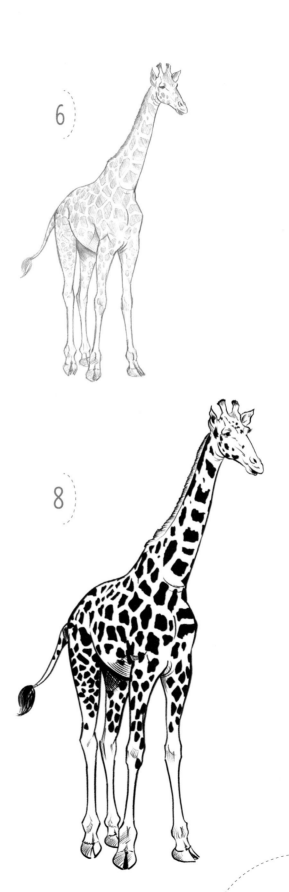

8

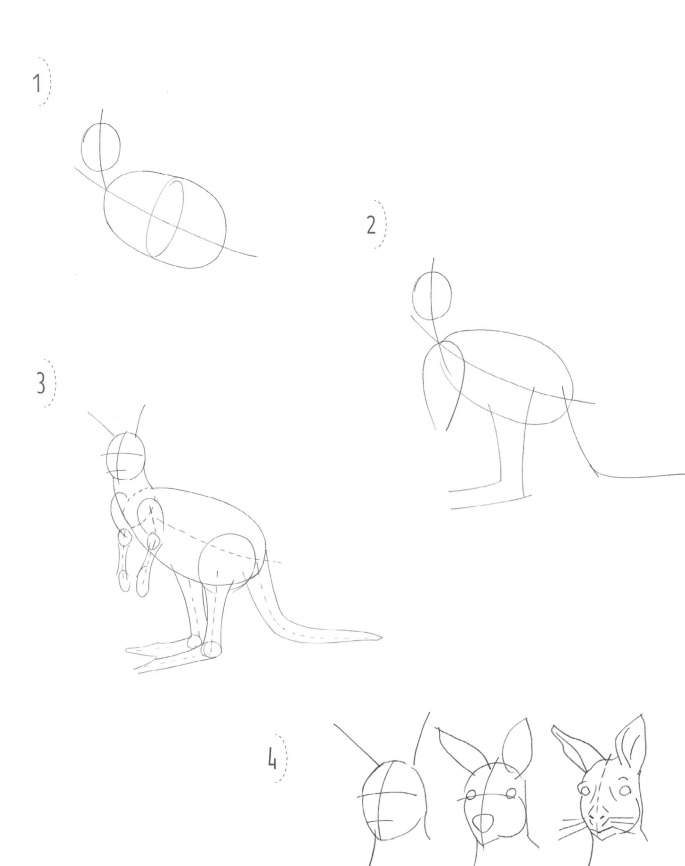

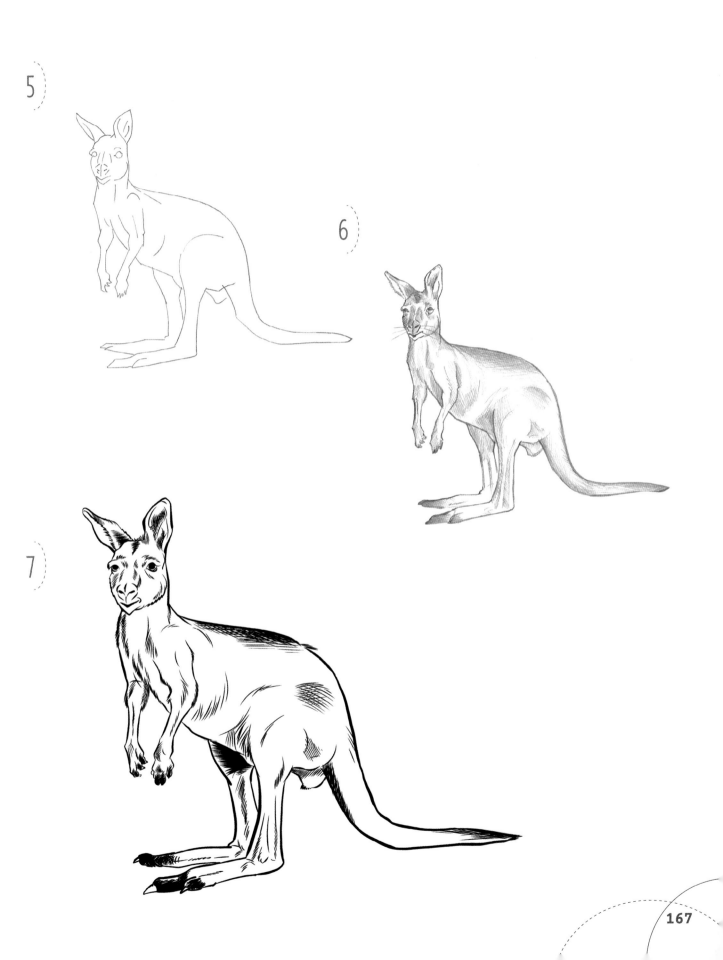

5

6

7

1

2

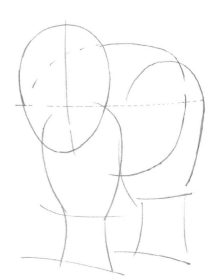

3

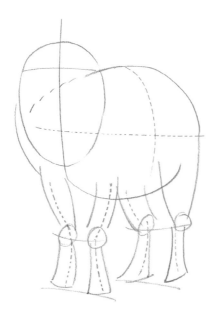

4

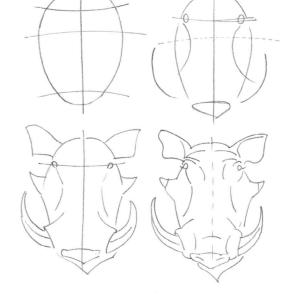

5

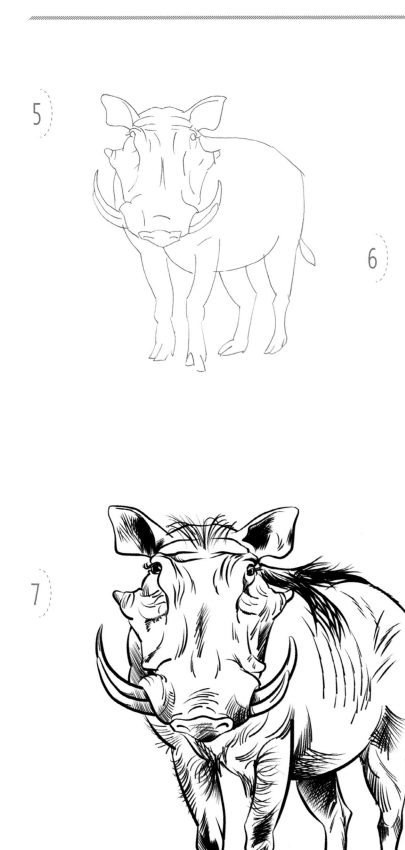

6

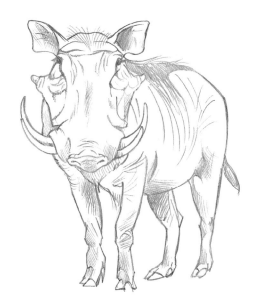

7

# GAZELLE

1

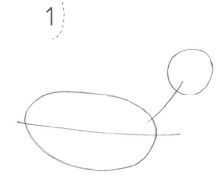

2

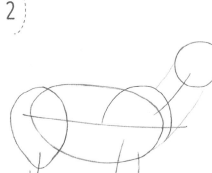

3

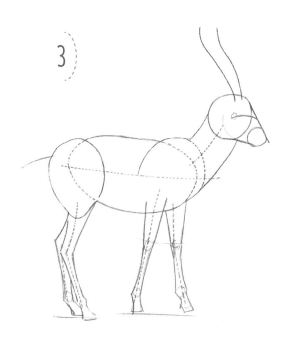

4

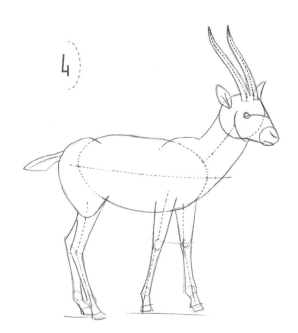

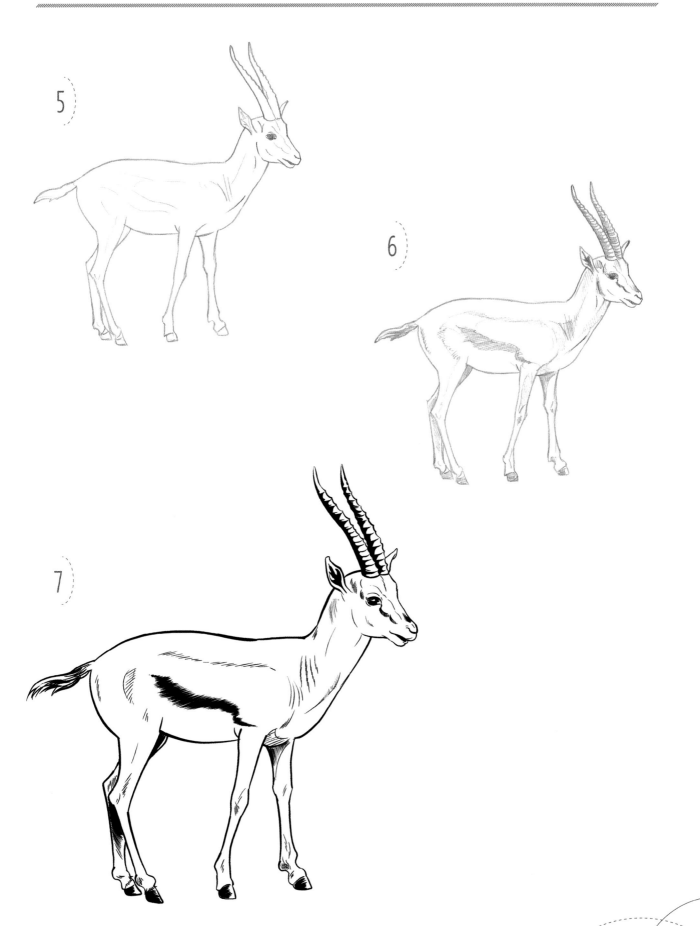

5

6

7

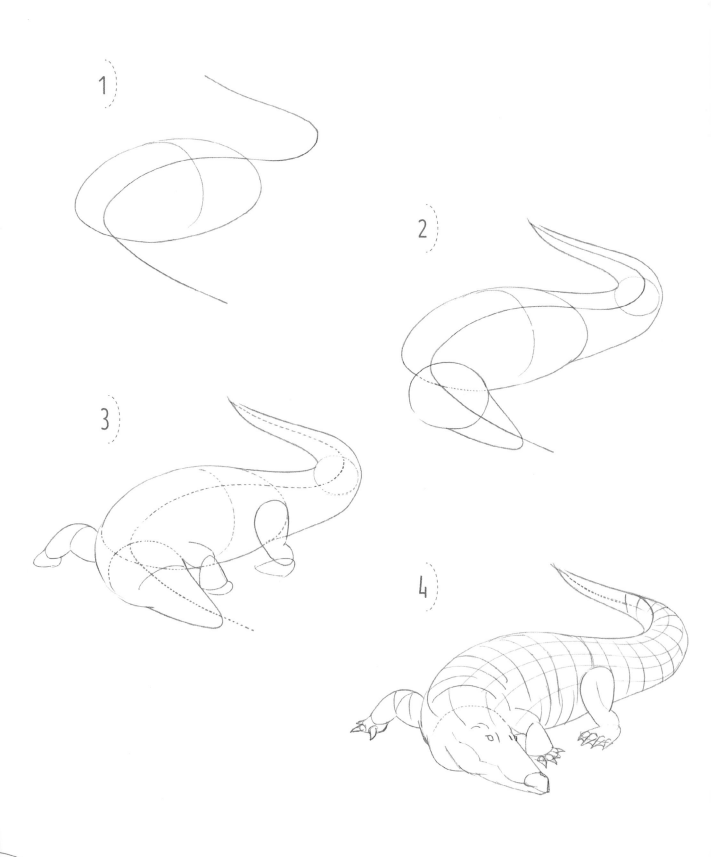

1

2

3

4

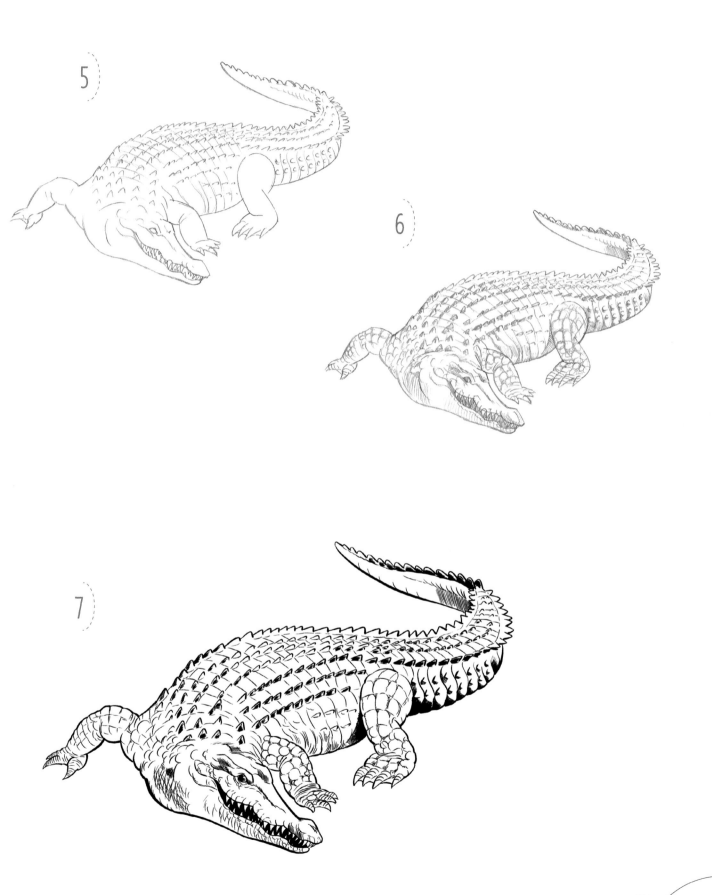

5

6

7

# POLAR BEAR

1

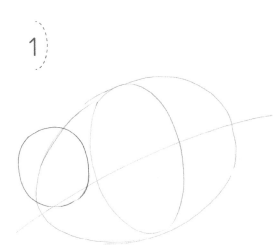

2

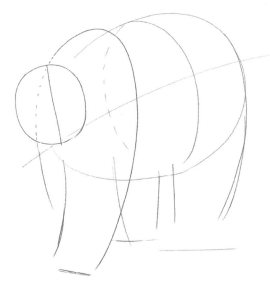

3

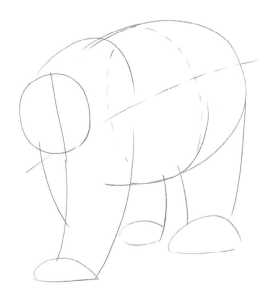

4

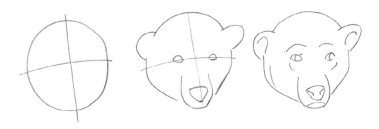

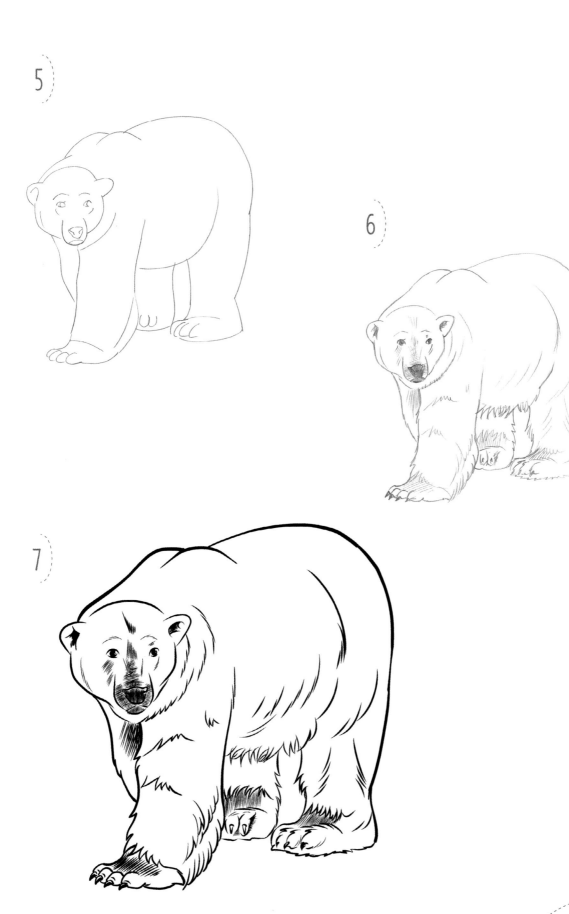

# PANDA

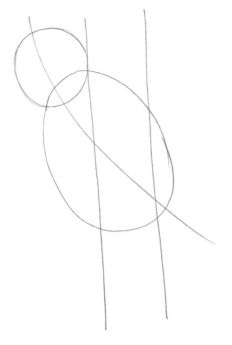

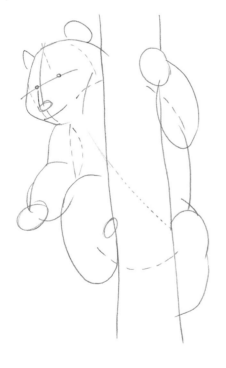

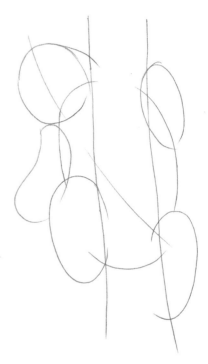

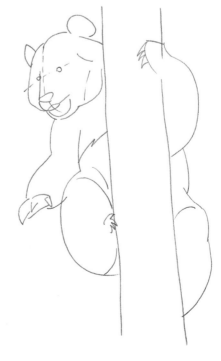

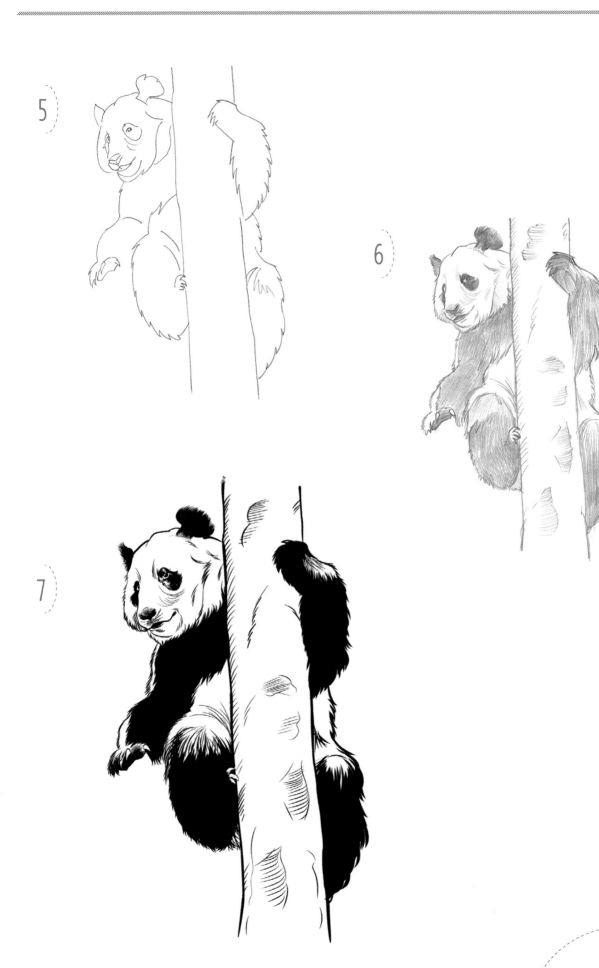

# GORILLA

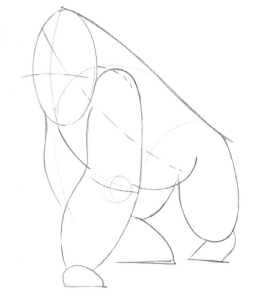

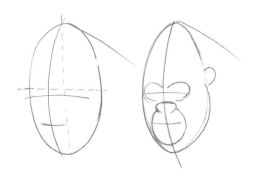

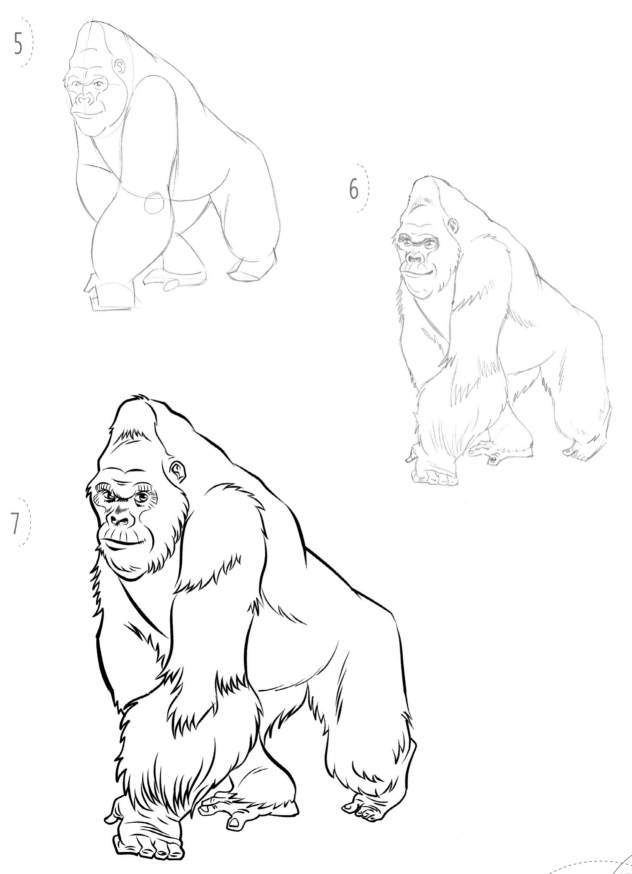

5

6

7

1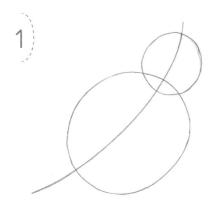

2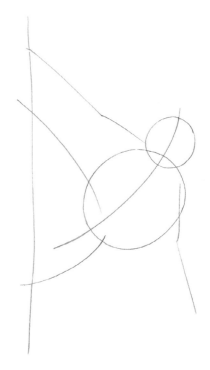

3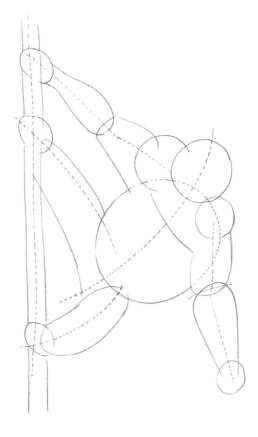

4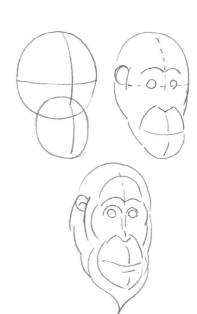

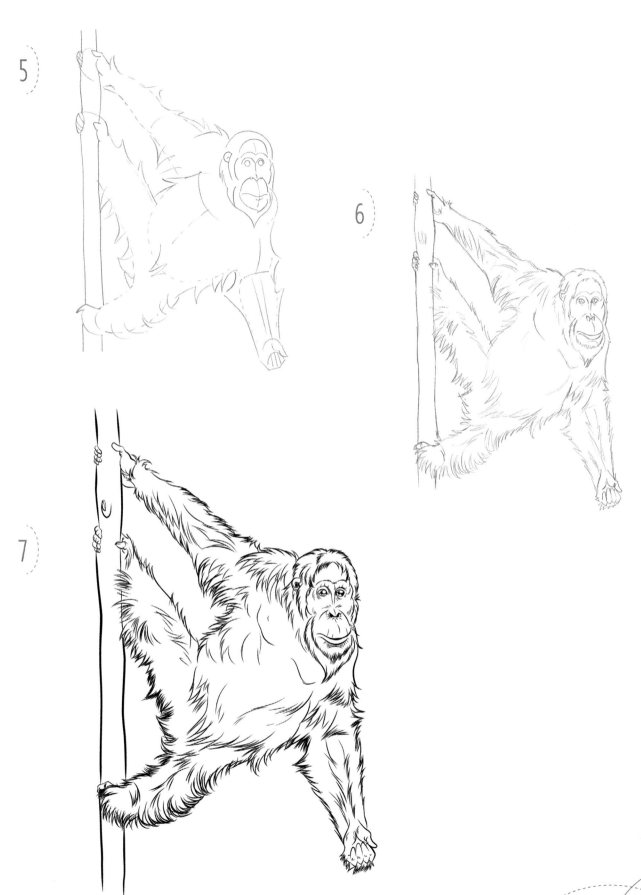

5

6

7

# MANDRILL

1

2

3

4

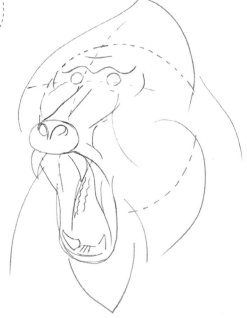

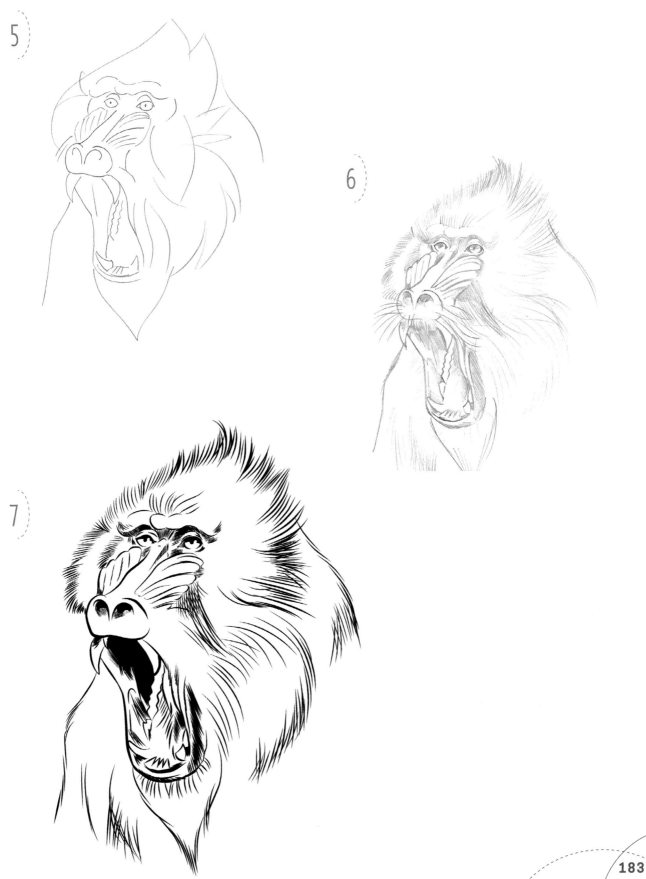

1
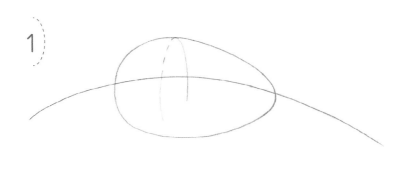

2

3
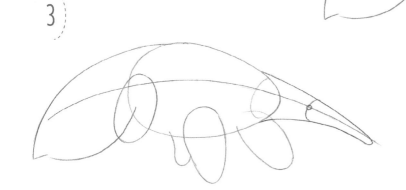

4

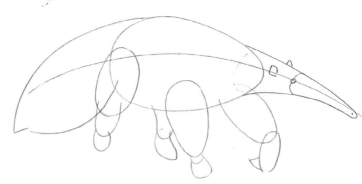

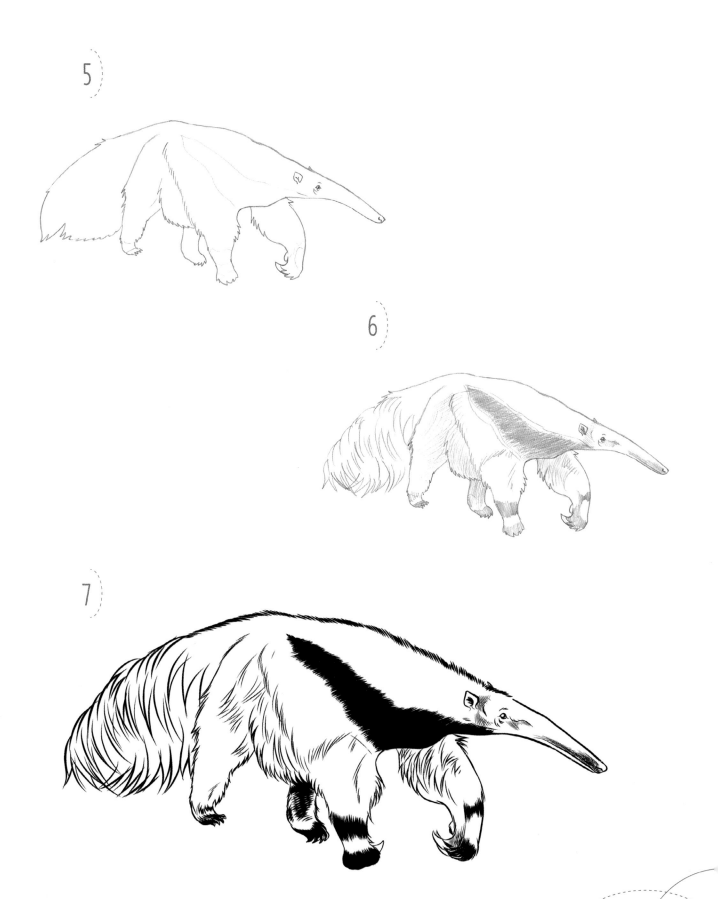

5

6

7

# ZEBRA

1

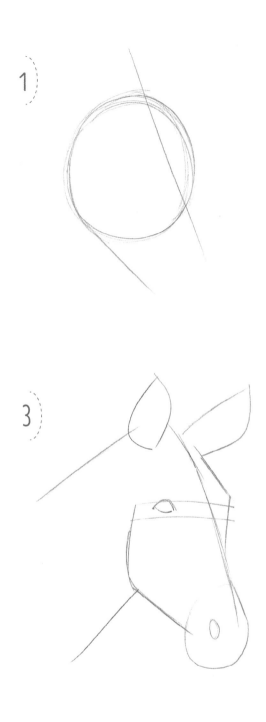

2

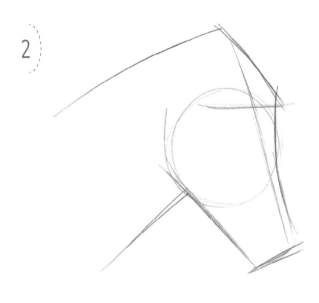

4

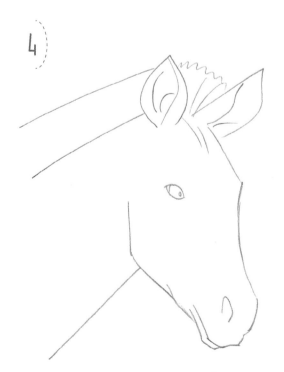

5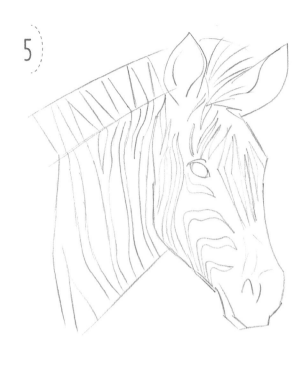

6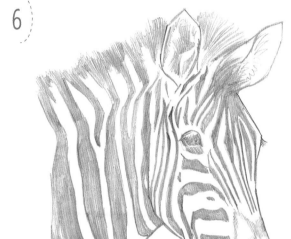

7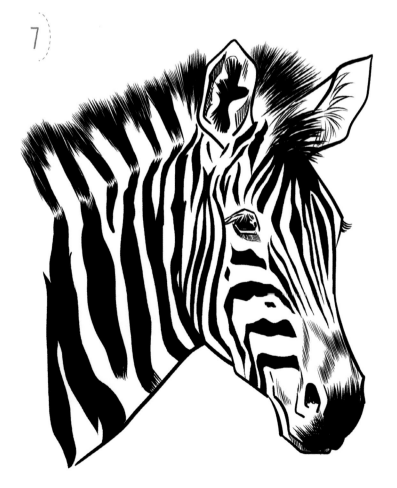

# HYENA

1)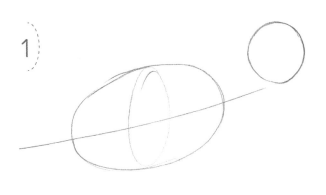

2)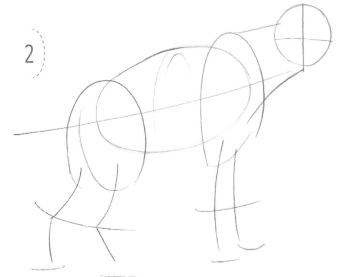

3)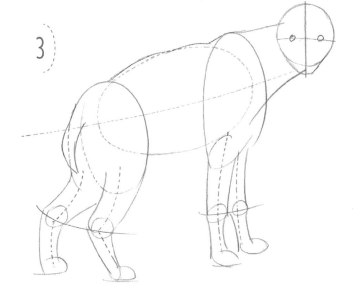

4)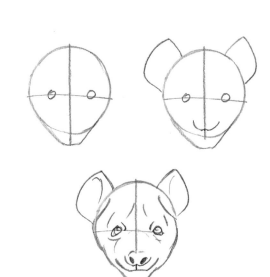

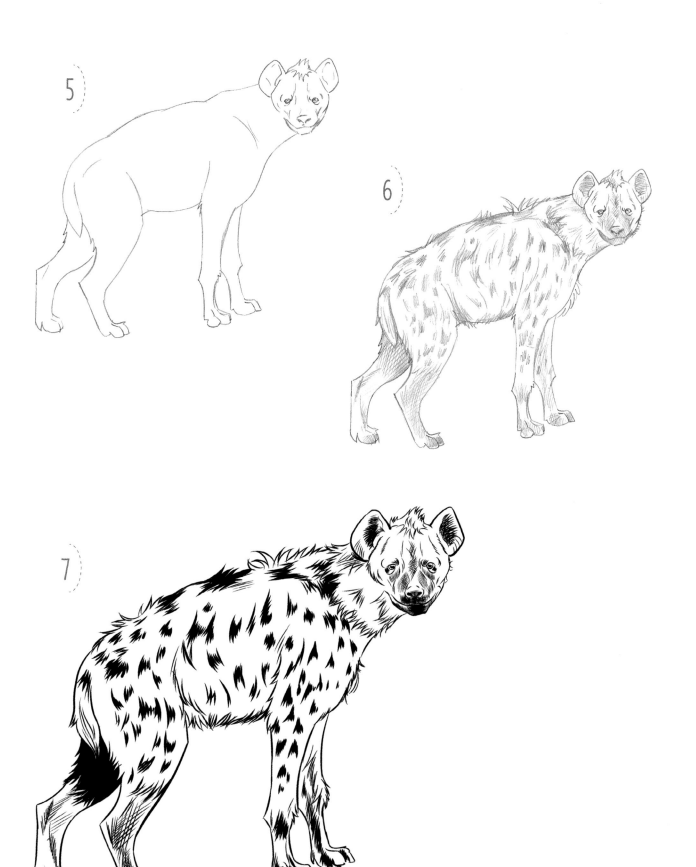

# INDEX

anteater, 184–185

bear, 18–19
Beluga whale, 120–121
boxer (dog), 44–45
butterflyfish, 122–123

cheetah, 156–157
chick, 12–13, 74–75
Chihuahua, 50–51
clown fish, 136–137
cocker spaniel, 52–53
collie, 54–55
crocodile, 172–173

dachshund, 72–73
Dalmatian, 56–57
deer, 16–17
dog, 8–9, 40–73
    anatomy, 40–43
    puppy, 8–9
    *See also specific breeds*
dolphin, 116–117
duck, 78–79

elephant, 22–23, 158–159
English bulldog, 46–47
English pointer, 64–65

fox, 34–35

gazelle, 170–171
German shepherd, 60–61
giraffe, 164–165
goat, 82–83
gorilla, 178–179

hammerhead shark, 146–147
hen, 74–75
hippopotamus, 160–161
horses
    anatomy, 92–93

dressage, piaffe step, 108–109
foal, 102–103
galloping, 100–101
heads, 94–95
on hind legs, 104–105
pony, 86–87
racing, 110–111
sleeping, 106–107
trotting, 96–99
humpback whale, 118–119
hyena, 188–189

kangaroo, 166–167
kitten, 6–7
koala baby, 24–25

lion, 150–151
    lion cub, 30–31
    roaring, 152–153

mandrill, 182–183
manta ray, 142–143
monkey baby, 28–29
Moorish idol fish, 122–123

narwhal, 128–129

octopus, 140–141
orangutan, 180–181
orca, 130–131

panda, 176–177
    baby, 26–27
Pegasus, 112–113
Pekingese, 62–63
penguin chick, 36–37
pig, 80–81
polar bear, 174–175
    cub, 4–5
pony, 86–87
poodle, 48–49

puppy, 8–9

rabbit baby, 10–11
raccoon baby, 20–21
rhinoceros, 162–163
rooster, 76–77

Saint Bernard, 66–67
sawfish, 138–139
schnauzer, 68–69
sea lion, 132–133
sea turtle, 148–149
seahorse, 124–125
seal baby, 38–39
sharks
    hammerhead, 146–147
    tiger, 144–145
Shar-Pei, 70–71
sheep, 88–89
    lamb, 90–91
Siberian husky, 58–59
squirrel baby, 14–15
starfish, 140–141
steer, 84–85
surgeonfish, 134–135

tiger, 154–155
    tiger cub, 32–33
tiger shark, 144–145

unicorn, 114–115

walrus, 126–127
warthog, 168–169
whales
    Beluga, 120–121
    humpback, 118–119
    narwhal, 128–129
    orca, 130–131

zebra, 186–187

a content + ecommerce company

Other fine North Light Books are available from your favorite bookstore, art supply store or online supplier. Visit our website at fwcommunity.com.

23  22  21  20  19     9  8  7  6  5

DISTRIBUTED IN THE U.K. AND EUROPE
BY F&W MEDIA INTERNATIONAL LTD
Brunel House, Forde Close, Newton Abbot, TQ12 4PU, UK
Tel: (+44) 1626 323200, Fax: (+44) 1626 323319
Email: enquiries@fwmedia.com

ISBN 13: 978-1-4403-5071-9

Edited by Beth Erikson
Designed by Breanna Loebach
Production coordinated by Jennifer Bass

Originally published in French by Éditions Vigot, Paris, France under the title: *Je dessine des animaux marins, Je dessin des animaux sauvages, Je dessine des animaux de la ferme, Je dessine des bébés animaux, Je dessine des chevaux* and *Je dessine des chiens*; 1st editions © Vigot 2009–2012.

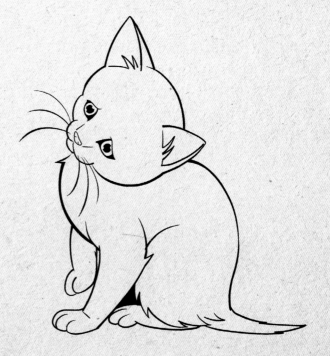

# IDEAS. INSTRUCTION. INSPIRATION.

Receive FREE downloadable bonus materials when you sign up for our free newsletter at artistsnetwork.com/Newsletter_Thanks.

Find the latest issues of *Drawing* on newsstands, or visit artistsnetwork.com.

These and other fine North Light products are available at your favorite art & craft retailer, bookstore or online supplier. Visit our websites at artistsnetwork.com and artistsnetwork.tv.

Follow North Light Books for the latest news, free wallpapers, free demos and chances to win FREE BOOKS!

## GET YOUR ART IN PRINT!

Visit **artistsnetwork.com/competitions** for up-to-date information on *Strokes of Genius*, *Splash* and other North Light competitions.

## GET INVOLVED

Learn from the experts. Join the conversation on